Web Design That Works

Secrets For Successful Web Design

ROCKPORT

GLOUCESTER MASSACHUSETTS

Web Design That Works

Secrets For Successful Web Design

ROCKPORT PUBLISHERS

Lisa Baggerman

Sidebars by Shayne Bowman

First published in the United States of America by

Rockport Publishers, Inc.

33 Commercial Street

Gloucester, Massachusetts 01930-5089

Telephone: (978) 282-9590

Facsimile: (978) 283-2742

www.rockpub.com

ISBN 1-56496-773-5

10 9 8 7 6 5 4 3 2 1

Design: Cathy Kelley Design/MATTER

Layout: Leeann Leftwich Zajas

Cover Image: Courtesy of Altoids®

Printed in China.

Eternal gratitude to the wildly creative people I interviewed for this book, who generously lent their time, wisdom, and expertise. My fine editor, Kristin Ellison, also deserves huge kudos, for her exceptional direction and encouragement along the way. I'd also like to thank my family, for always wanting to be the first people with a copy of my book in their hands and Shawn, for the love of design he brings to our home, and the inspiring skill he exhibits in his own work. This book is dedicated to him.

CONTENTS

1:11PM

HOMER STREET, VANCOUVER, CANADA

inutes downto

INTRODUCTION

It's the conundrum of Web design: There are millions of sites and so few worth visiting. The fact that anyone with a computer can publish a site is a big part of the problem—and unfortunately for many companies, this is their only Web strategy.

A common misconception is that if you've already worked in design and have learned the language, you can jump right into Internet design. But there's much more to Web design than code. The Web is vastly different from print, or any other design discipline, for that matter. Successful Web design means taking a different tack, considering the user experience first and embellishments second to create a dynamic, provocative, active destination.

Despite the fact that the number of people using the Web is growing exponentially—literally the majority of the population—the number of sites servicing this booming traffic will eventually shrink and the survivors will be the ones who have anticipated and met user needs. Here are some elements you'll find in successful sites.

TURN THE TABLES

If you've ever been told that you never know someone until you take a walk in their shoes, you already know the first rule of successful Web design. Web design is about creating an active experience for your visitors, so it is paramount to not only research what your audience wants but to really pinpoint the specifics. By 2001 there will be an estimated one hundred million websites. This means that users will and are losing patience plowing through the numerous sites that turn up with each search, so you must offer a focused and well-organized site in order to survive.

CONTENT, CONTENT, CONTENT

Simply put, content is the most valuable resource any site has. The more, the better, just make sure it's good and always keep it updated. Content is the hook, and keeping it updated will keep users coming back.

NAVIGATION

A site can have the greatest, most innovative content ever, but without an intuitive site-navigation system, it will all be lost on users. Users simply won't spend time hunting for information—they know there's always something somewhere else. The key is to keep the access to your content as intuitive and linear as possible. Link and cross link information, so there's more than one way to find it.

MAKE A CONNECTION

It doesn't matter who you are—you've got competition. With the millions of pages vying for visitors' time, sites need to do more than passively post information. The site should be a point of interaction—where users become active participants. This could include feedback forms, interactive games, or registering visitors and using their preferences to deliver a personalized experience. The important thing is engaging users as active participants.

All this makes for great advice in theory, but how do you put it into practice? Here are some sites that use their design to make their site a valuable tool.

E-COMMERCE

2001

C14

Chris Brown

jewelry
EXPERTISE

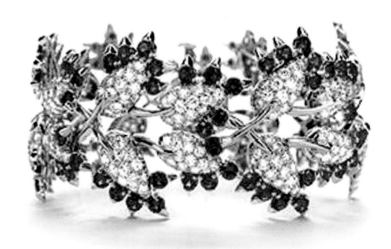

The launch of the Internet spurred an industry boom—pretty much anyone who considered himself an analyst was boldly predicting that the Web would squash brick-and-mortar retailers. If people didn't have to leave home to do their shopping—if they were able to have absolutely anything they needed delivered to their home—how could traditional stores compete?

The dawn of the twenty-first century effectively dashed these predictions. Physical stores remained as strong as ever, while dot-com retailers folded one by one. While there was a lot of finger-pointing and blame passed around, the hard truth was that, in most cases, the Internet retailers weren't yet ready or able to compete. Sites weren't designed to be user-friendly, technology was shoddy, customer service was nil. Online retailing pioneers learned the hard way that simply allowing people to shop online wasn't enough—that in order to succeed, retailers would have to incorporate several of the elements of traditional, in-store shopping in their sites.

There's a lot to learn from the following sites, and most of these cues don't have to do with technology or design, but rather with learning from the successes of traditional in-store shops. Consider Red Envelope 's copious customer service center. With three different ways to contact Red Envelope, including live, online chat with customer service representatives, shoppers won't feel that they're floundering in cyberspace.

Tiffany.com draws extensively from its successful parent store, luxury retailer Tiffany & Co., for a sophisticated, elegant approach. The site is designed to approximate the in-store experience of shopping at Tiffany's as much as possible, with high-quality images representing the Tiffany products and detailed product information to supplement the advice of a sales associate.

Other sites seize the power of the Web to gain a competitive advantage. Technology offers one such advantage in the form of customization. Customatix.com allows customers to personally design athletic shoes to order on their site, personalizing every last detail. (Try doing that in your local Athlete's Foot store.) As Customatix's Mikal Peveto says, "Customization is soon to be the rule and not the exception to it—especially in the e-commerce side of the business world."

The capacity to remember customer information and sort and organize products can help online stores save time for repeat customers. Webvan.com helps you accomplish things you won't be able to do in any other store—immediately track down items from past orders and put toothpaste right next to peanut butter in your personal market. Furthermore, Webvan's powerful search technology allows visitors to quickly find products and sort search results in several ways.

And the Web can be used to convey an essential sense of style as well. Burton.com chose to create an immersive, high-intensity site to appeal to the snowboarding audience.

CHEAT SHEET

Navigation: Essential, especially when the site offers many different products.

Aesthetics: The site design should take a backseat to the product. Design elements should include tools to help access products

Search: Essential—get inside the head of the user to determine how

Cutting-Edge Potential: Leave it to the programmers and engineers! The design should be simple and accessible to anyone.

Copy Style: Succinct and informative.

REDENVELOPE.COM

REDENVELOPE.COM: SIMPLICITY EQUALS SUCCESS

RedEnvelope's design is simple and elegant on the surface,
mighty underneath. Their basic approach melts away the
obvious site structure and leaves users free to explore
their products.

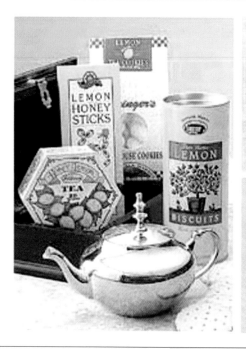

grandparents' day

It's your turn to spoil them.

Grandparents' Day is September 10th! Whether your
kids have just learned to say "Grandma" or you're still
calling your own Granddad for advice, grandparents
deserve to be spoiled too.

Back to School! Send your whiz kid something to get
them through the fall semester.

english tea time $75.00
amber heart necklace $30.00
pocketwatch frame + keepsake box $30.00

Workshop

RedEnvelope is an online retail site that specializes in online gift shopping and delivery. The site's philosophy is: "Gift-giving should be effortless, but it should also be meaningful," a mantra echoed through the minimalistic design, choice products, and small touches like elegant giftwrapping options.

What Works

In an e-vironment where sites scream at consumers from every corner of their screen, RedEnvelope takes a decisively different approach. The design is muted, understated, and minimalistic. Rather than cramming as many products as possible onto the home page, designers use this page to feature an ever-rotating selection of two or three products. RedEnvelope doesn't mess with the positioning of the navigation bar, anchoring it in the top of the page, and allowing users access to two tiers of navigation from here.

Work Wisdom

RedEnvelope's minimalistic approach echoes the company's style from every pixel, effectively branding the site and framing the site experience: The design is about scale, style, and sophistication.

Behind the simple design lies a mighty site-navigation structure, shrouded by a user-friendly interface. Most notable is RedEnvelope's humanistic approach to searches. Pull-down menus on the Gift Search page allow the user to search in familiar terms. The user selects who the gift is for (boyfriend, girlfriend, baby, pet), the occasion, price range, and the recipient's interests. With this information, RedEnvelope scours its database of products and retrieves a filtered search of appropriate products.

Good customer service is absolutely essential for any retail site, and RedEnvelope smartly offers users a variety of options. When the user clicks on the Customer Service tab, they are provided with a variety of choices for how to contact customer service, including e-mail, a toll-free number, and most cleverly, a live on-line chat with a customer service representative. By integrating this into the site, RedEnvelope bridges the perceived customer service advantages of in-store shopping online.

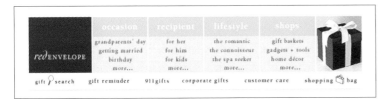

Opposite and this page: Designers for the RedEnvelope site aren't afraid of white space— the site features the bare minimum of elements for the maximum impact. The high-quality photography gives visitors a good sense both of the products and of the site's personality.

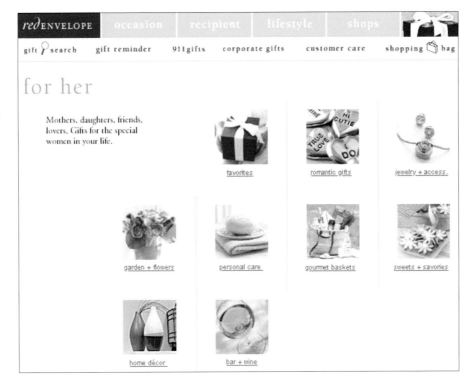

left: The design of the RedEnvelope site is extremely clean and modular. A welcome departure from e-commerce sites that cram the home page with as many products as will fit, RedEnvelope is designed to evoke the character of a classy retail store. The home page features four tasteful photographs, accompanied by static navigation links along the top and teaser text to the right.

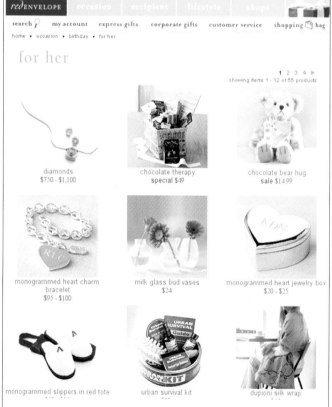

above and left: The structure of the RedEnvelope site takes into account the way people shop for gifts. Rather than leaving visitors to plow through general product groupings, items are organized by occasion, recipient, and lifestyle. It's easy to browse gifts by exploring these different areas, whether you're looking for a housewarming gift or something appropriate for a business associate.

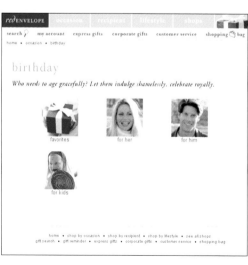

right and below left: RedEnvelope takes advantage of the ability to create mini stores within the site in the "Shops" area. Here, visitors can browse products within special niches like the "Pets" gift shop.

below right: Beyond the powerful, thoughtful Browse function, there are a variety of ways to search the RedEnvelope site. Users can target searches by price range or by item number, or they can flip virtually through the site's print catalog.

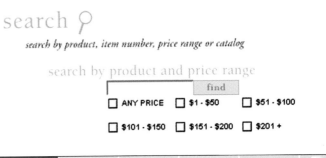

right: The site is designed to accommodate finding gifts for particular occasions, like anniversaries. The clever structure of the site links appropriate products across categories—products are given new points of reference depending on the occasion, personality, and recipient.

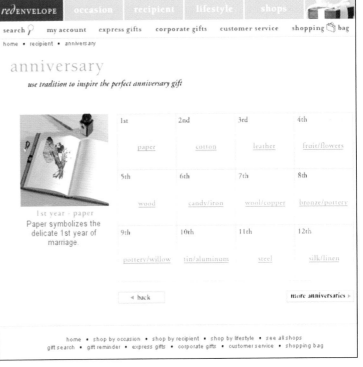

CUSTOMATIX.COM

GIVING PEOPLE WHAT THEY WANT

The Jetsons can be credited with a significant role in molding the public's perception of the role technology would take in the future. The TV cartoon series propagated the concept of being able to press a button and have the perfect product—anything from a car to a tailored suit—pop out of a slot. While technology hasn't yet achieved that level of sophistication, one aspect of *The Jetsons* vision has been realized—the opportunity to use the Web as a tool for precise customization. For instance, online shoe retailer Customatix.com isn't just selling a warehouse of shoes to the consumer—that's so twentieth century. Instead, this site gives its visitors the opportunity to design and purchase completely unique shoes created using the site.

right: Customatix is not your average e-commerce site. Instead of presenting the visitor with a bunch of different premade items to choose from, the site encourages visitors to start designing their own creations by assembling one of the literally millions of combinations available.

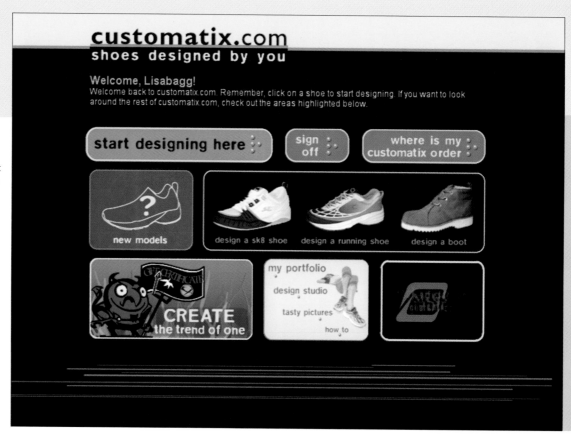

right: Visitors can either personalize an existing design or start with a blank slate for the style of shoe chosen. Registered users can save their creations to their personal portfolio and come back to modify or purchase the shoes later.

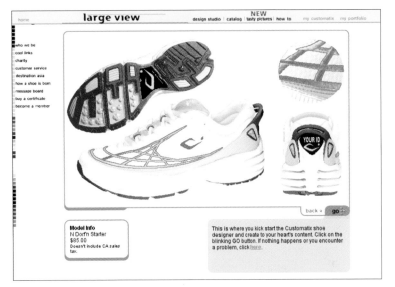

Workshop

Customatix is a Santa Cruz, California–based site that allows visitors to design and purchase customized athletic shoes.

What Works

The shoe consumer's desire for unique, personalized footwear gave Customatix the impetus to build the site. Modern technology made it possible. "We wanted to create something that exploited the single most emotional aspect of athletic footwear—design," says Mikal Peveto, Customatix's "director of creative chaos." "Since we give the power of choice to consumers, we instantly have a position of strength. No matter how good a retailer's buyer is, how can he/she make a decision that will please everyone?"

The result of Customatix's experimentation is nearly infinite opportunities for the customer to build unique designs. The choices include different shoe styles, fabrics, logos, colors, and more. But the site's structure isn't strictly business. Its design and the tone of its copy encourage visitors to experiment with different designs, save them in personal portfolios, and send them to friends. The entire process is fun and creative, invoking the creativity of the user.

Work Wisdom

Customization is one of the best ways to connect with users when it comes to e-commerce—it's an element not available through most brick-and-mortar market channels. "Customization is soon to be the rule and not the exception to it, especially in the e-commerce side of the business world," Peveto says. "People want control in what they buy—why not give it to them? E-commerce is a channel of distribution that will grow and continue to do so for the foreseeable future."

But Customatix doesn't rely completely on customization to sell its shoes. Knowing that a public used to buying from shoe stores would need to make a leap of faith to buy custom shoes online, the site developers made special concessions to help bridge the gap between brick-and-mortar stores and the Web. Details about the shoes' technical composition are communicated through Flash movies, and the "shoe theater" shows different commerciallike takes for each shoe style, evoking the personality of each style. Information about the different fabrics used is also included, and a downloadable PDF allows visitors to easily measure their shoe size.

"I like to say, 'Where else than the Web can you shop for boxers wearing only boxers?'" says Peveto. "It may not be the George Jetson world I once envisioned where you push a button and out pops a shoe, but it's the smartest and best way for a business like Customatix to exist."

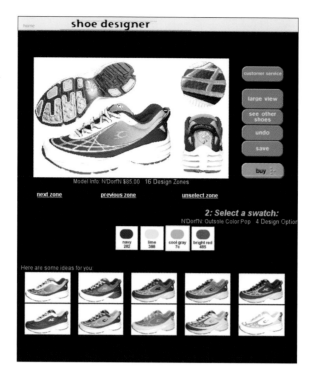

Model Info: N'DorfN $85.00 16 Design Zones

next zone **previous zone** **unselect zone**

2: Select a swatch:
N'DorfN: Outsole Color Pop 4 Design Option

navy 282 lime 388 cool gray 7c bright red 485

Here are some ideas for you:

left: Users are provided with dozens of options, including everything from the colors used on the soles to the graphics on the shoes. To prevent creative block and provide inspiration, Customatix thoughtfully provides a series of design ideas along the bottom of the screen.

below: Users can get a detailed look at the available textures, fabrics, colors, and patterns in the different galleries. Providing details like these is essential to bridging the gap between brick-and-mortar stores and the new world of e-commerce.

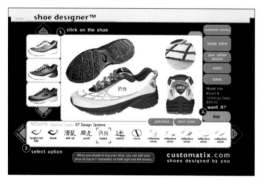

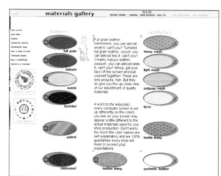

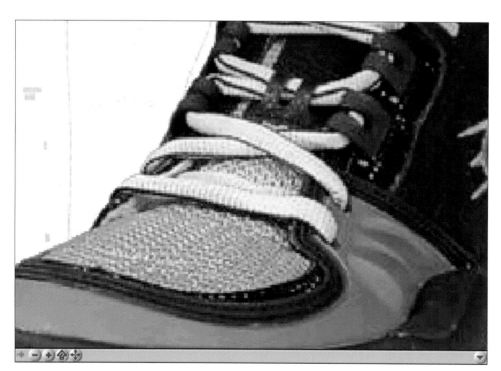

left and below: Customatix used QuickTime VR to provide 360-degree views of the shoes, the online equivalent of picking up the shoes and getting a close look at them. The site takes every opportunity to use technology to bridge the gap between the online and tactile experiences.

right: The information on the site underscores that the shoes created aren't just eye candy. Different features show off the sophisticated design features built into each shoe. Short Flash movies show off the shoe's features.

below: It was natural to incorporate a community for Customatix users, since the experience of creating shoes on the site is such an opportunity for self-expression and creativity. The message boards allow users to provide design ideas, brag about their own designs, and get customer service help.

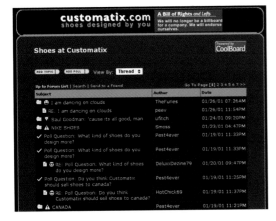

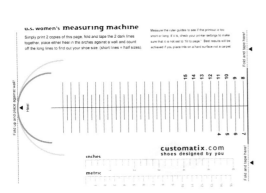

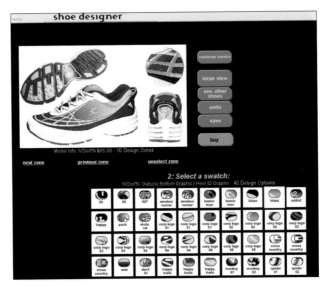

far left: Great lengths are taken to bridge the gap between brick-and-mortar stores and online shopping. A downloadable PDF measuring chart helps visitors determine their correct size, an online solution to the metal measuring devices seen in traditional shoe stores.

left: Although the site is slickest when experienced in Flash, an HTML version is provided for visitors without the Flash plug-in. The design assures that not much is lost in the translation—the HTML version includes a cohesive design and navigation elements that help users quickly design their shoes.

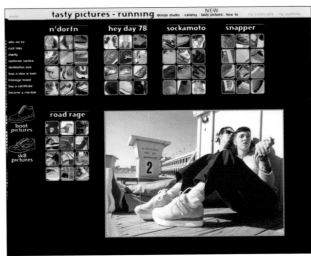

left: The "hip" factor of shoes is essential in this market—a fact that wasn't overlooked in the design of this site. The "Tasty Pictures" show Customatix shoes in action, worn by hipsters in super-cool settings.

click-and-mortar

Your online brand and your offline store brand are inextricably linked for the user. There is no separation between The Gap and gap.com.

The Web is now a standard mode of communication and commerce with your customer.

It is important not only to incorporate the marketing message of your brand in your website, but also to integrate the brand experience of your e-commerce site with that of your brick-and-mortar store.

opposite: On Nike.com, Web users can locate the nearest store selling Nike products, find factory outlets, and learn about special events hosted at Niketown stores worldwide. They even show pictures inside the Niketown stores. © NIKE RETAIL SERVICES, INC. 2000—NIKE.COM

Create symmetry in the buying experience: If you see a product at a store or in a catalog, allow users to locate the item online by using the product number. On the Websites of retailers like Neiman Marcus, Nordstrom, and Pottery Barn, this service is called Catalog Quick Shop or Catalog Quick Order. Conversely, any product purchased online should be returnable at the physical store. Niketown, Best Buy, The Gap, and JC Penney have adopted this idea, and it's becoming a standard of service. Several companies are trying to solve the logistics of buying online and picking up the product at the store. Another emerging practice enables users to search your store inventory online and place a hold on the item so they can pay and pick up the item in person.

Offer a store locator: Make it easy for customers to find out where the nearest stores are located. If you have outlet stores, make sure users can find them using the same locator service. Integrate the locator service with maps and driving directions, hours of operation, types of payment accepted, and, if applicable, what's special at the location. If you have special events at your stores, such as book signings or celebrity appearances, make sure the online audience knows about them.

Emphasize customer service: Enable users to contact you any way they wish, online or off. On every page, there should be a link to a list of names, e-mail addresses, and phone numbers of service representatives, as well as phone numbers for general inquiries in the U.S. (and abroad, if applicable) and a full mailing address.

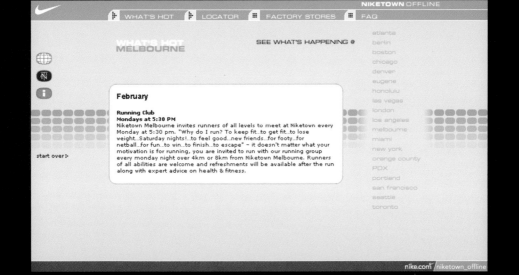

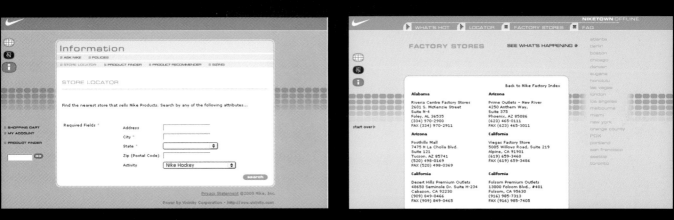

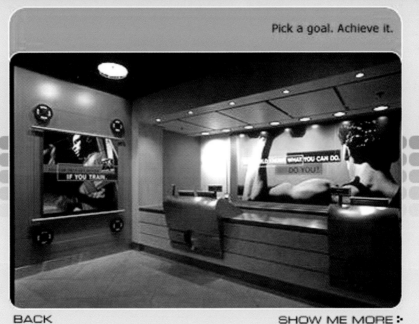

TIFFANY.COM

ELEGANT FLASH

Macromedia's Flash brings more to Web design than just bells and whistles, but you'd never know it from looking at the many Flash sites that use the technology solely to create aesthetic effects like sophisticated animations and integrated sound. Don't sell Flash short—it's a powerful tool when used in conjunction with a site's navigation and core structure. Take, for example, the practical use of Flash in the Tiffany.com site—it's used to subtly power the site navigation, allowing visitors to make seamless transitions among the site's sections.

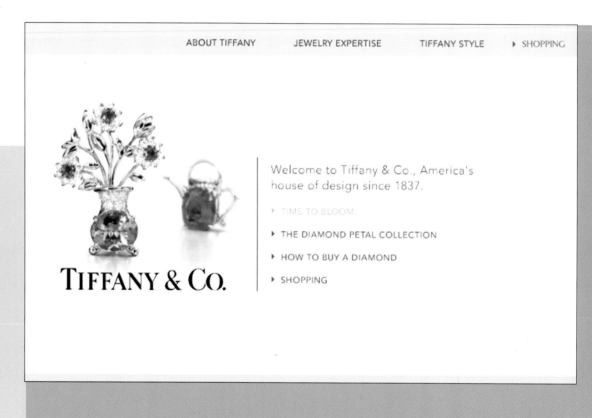

Workshop

Tiffany.com is the online presence for Tiffany & Co., the legendary retailer of luxury jewelry. The site was designed by OVEN Digital, a multimedia design firm.

What Works

Shopping at Tiffany's traditional stores is a sophisticated and refined experience—a concept that was integrated into the design of Tiffany.com. "We wanted to evoke some of the 'real world' experiences you get when you visit a Tiffany store," says Karen Lee, lead designer for OVEN Digital, Sydney, Australia. "For instance, the feeling you get when you walk into the main store on Fifth Avenue in New York City or when a sales associate takes out a piece of jewelry from under a glass counter. It was really important for us to translate all of these things online in ways that were not clichéd and that suited the medium."

The overall site structure was designed to be minimalist, allowing the beautiful Tiffany products to carry the design. Since the trademark Tiffany blue didn't translate well online, designers chose to use a warmer palette. "The colors we chose allowed us to generate the type of energy that's more suitable to an Internet space," says Lee. Similarly, the photography had to evoke the heart of Tiffany's business—quality. OVEN used only high-quality digital photographs of all the items. "It was important to show the highest detail possible in photographs, since [the photographs] had to replace the user's ability to pick up an object and turn it over herself," says Lee.

Work Wisdom

At first blush, a Flash site for Tiffany's seems antithetical—too ostentatious for the elegant Tiffany brand. "We used Flash differently from how other sites were using Flash at the time," says Lee. "What was being created seemed to be more about bringing attention to the fact that Flash was being used rather than for any specific design need. We used it purely to navigate, so it was never treated in a gimmicky way and it never became secondary to the goals of the design."

above and right: It was especially important for designers to use well-photographed images to provide flattering representations of the products in the site design, since the nature of Tiffany's business is so high-end. Special consideration was given to the appearance of the metal surfaces, scaling, and color.

left: Shopping the Tiffany site is more than just shopping carts and product descriptions. The site includes changing features, advice on how to buy a diamond, featured products, and more.

TIFFANY & CO. ABOUT TIFFANY JEWELRY EXPERTISE **TIFFANY STYLE** SHOPPING

create a
TABLESETTING

We invite you to create a visual
display of your favorite Tiffany
china and silver flatware. Just select
from among the patterns below.

▶ BACK TO 'AT THE TABLE"

CHINA
▶ SILVERWARE : Hampton

BRIDAL REGISTRY TIFFANY FOR BUSINESS CUSTOMER SERVICE STORE LOCATIONS CATALOGUES SITE INDEX

above: Though the site uses slick
Flash technology, it's careful to
do so in a very subtle way. In no
part of the site does the Flash
draw attention to itself—it's sim-
ply used for navigation and
interface elements, as on this
page, which invites users to
design their own table setting
using Flash technology.

right: The overall feeling of the
Tiffany site is elegant minimalism.
Since the trademark Tiffany blue
didn't translate well online,
designers selected a warm
palette that didn't overwhelm
the page. Photography is given
major play against a white
backdrop and the amount of
information on the site is
controlled by vertically
scrolling text.

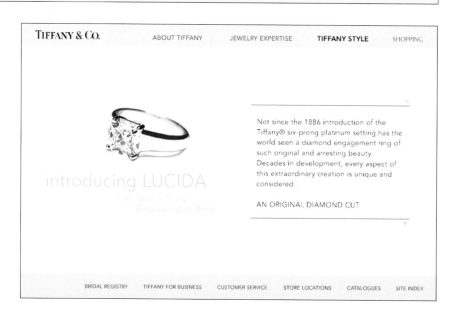

TIFFANY & CO. ABOUT TIFFANY JEWELRY EXPERTISE **TIFFANY STYLE** SHOPPING

introducing LUCIDA
The New Tiffany
Engagement Ring

Not since the 1886 introduction of the
Tiffany® six-prong platinum setting has the
world seen a diamond engagement ring of
such original and arresting beauty.
Decades in development, every aspect of
this extraordinary creation is unique and
considered.

AN ORIGINAL DIAMOND CUT

BRIDAL REGISTRY TIFFANY FOR BUSINESS CUSTOMER SERVICE STORE LOCATIONS CATALOGUES SITE INDEX

TIFFANY & CO.

ABOUT TIFFANY JEWELRY EXPERTISE TIFFANY STYLE SHOPPING

SEARCH JEWELRY COLLECTIONS GIFTS TABLETOP

Diamond line necklace, with Victoria clasp. Platinum; 85 round brilliant diamonds, carat total weight 21.85, and four marquise diamonds, carat total weight .55, color grade G-H, clarity grade VVS.
$120,000

ENLARGED VIEW | INDEX | SEARCH

▶ CHOOSE YOUR QUANTITY 1 2 3 4 ▶ PROCEED TO PURCHASE

Necklaces ▲

800-843-3269 BRIDAL REGISTRY TIFFANY FOR BUSINESS CUSTOMER SERVICE STORE LOCATIONS CATALOGUES SITE INDEX

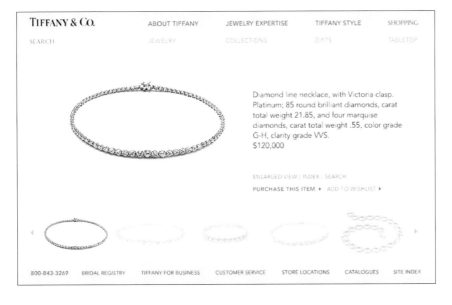

TIFFANY & CO.

ABOUT TIFFANY JEWELRY EXPERTISE TIFFANY STYLE SHOPPING

SEARCH JEWELRY COLLECTIONS GIFTS TABLETOP

Diamond line necklace, with Victoria clasp. Platinum; 85 round brilliant diamonds, carat total weight 21.85, and four marquise diamonds, carat total weight .55, color grade G-H, clarity grade VVS.
$120,000

ENLARGED VIEW | INDEX | SEARCH
PURCHASE THIS ITEM ▶ ADD TO WISHLIST ▶

800-843-3269 BRIDAL REGISTRY TIFFANY FOR BUSINESS CUSTOMER SERVICE STORE LOCATIONS CATALOGUES SITE INDEX

above and left: Since shopping at Tiffany's is such a unique experience, designers hoped to translate some of the elegance of the brand online. The products on the site are presented graphically, with seamless transitions between areas.

TIFFANY & CO. ABOUT TIFFANY JEWELRY EXPERTISE **TIFFANY STYLE** ▶ SHOPPING

paloma
PICASSO

Paloma Picasso

Born in Paris to Pablo Picasso and Francoise Gilot, Paloma Picasso first became a theatrical costumier and stylist for avant-garde productions, where her talent for jewelry design emerged. In 1979, Ms. Picasso was invited to present a table setting for one of Tiffany's exhibitions. A year later, Tiffany introduced Paloma Picasso's first exclusive collection of jewelry, which was instantly embraced for its innovative "graffiti" motifs, bold scale and brilliant

BRIDAL REGISTRY TIFFANY FOR BUSINESS CUSTOMER SERVICE STORE LOCATIONS CATALOGUES SITE INDEX

above: Since Tiffany's product line is so high-end, it's important for them to provide visitors with as much information as possible to underscore the company's emphasis on quality. In the shopping area, the site introduces visitors to jewelry designers with brief biographies.

right: One of the areas where visitors may miss brick-and-mortar stores is in online shopping's lack of the advice and guidance that a sales staff offers. Although the Tiffany Website could never replace actual one-on-one contact with Tiffany customers in retail stores, it does provide advice on how to find the quality of item that one is looking for on the site.

TIFFANY & CO. ABOUT TIFFANY **JEWELRY EXPERTISE** TIFFANY STYLE SHOPPING

jewelry
EXPERTISE

HOW TO BUY A DIAMOND

HOW TO BUY PEARLS

TIFFANY MATERIALS

CARING FOR YOUR JEWELRY

BRIDAL REGISTRY TIFFANY FOR BUSINESS CUSTOMER SERVICE STORE LOCATIONS CATALOGUES SITE INDEX

TIFFANY & CO.

SEARCH

ABOUT TIFFANY JEWELRY EXPERTISE TIFFANY STYLE SHOPPING

JEWELRY COLLECTIONS GIFTS TABLETOP

Bracelets ▲
Brooches
Cufflinks
Earrings
Engagement
Necklaces ▼

SHOPPING

Tiffany & Co. is a sumptuous emporium of classic jewelry
designs and fine tabletop collections. This is the place to
celebrate life's most important moments with gifts of
extraordinary beauty. Here at Tiffany.com, you will see a few
of our favorite designs. Please visit a Tiffany store to view our
complete offering.

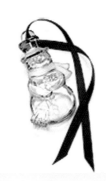

Snowman ornament in full lead crystal.

800-843-3269 BRIDAL REGISTRY TIFFANY FOR BUSINESS CUSTOMER SERVICE STORE LOCATIONS CATALOGUES SITE INDEX

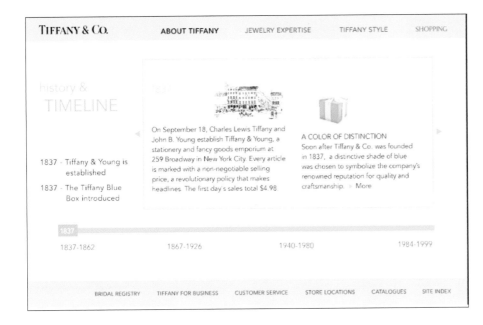

above: Flash is used primarily
for navigational elements, like
these drop-down menus that
provide a very simple and
uncluttered way to navigate the
site and allow people to avoid
being overloaded with choices.

left: While the site provides an
immersive shopping experience
for visitors, it also includes prac-
tical information like the history
of Tiffany's and investor data.

BURTON.COM

PUSHING TECHNOLOGY

There's a lot of debate surrounding how far to push Web design technology. Some site designers swear by the lowest-common-denominator philosophy, going to great lengths to make sure no matter what their connection speed, platform, or browser, all users will enjoy equal access to the same information. Other designers strive to push the envelope, aggressively using technology to make their websites sizzle, even if it means sacrificing some lower-bandwidth users along the way. The secret of knowing what approach to take for a site boils down to one variable—the intended user.

right: The first thing that visitors see when they reach Burton.com is a warning that they are in for a rich site experience, which also lets them know what tools they will need to access the website. The designers chose to create a technologically charged site because they thought the progressive design and pro-gramming would echo the corporate philosophy displayed in the company's radical snowboard designs.

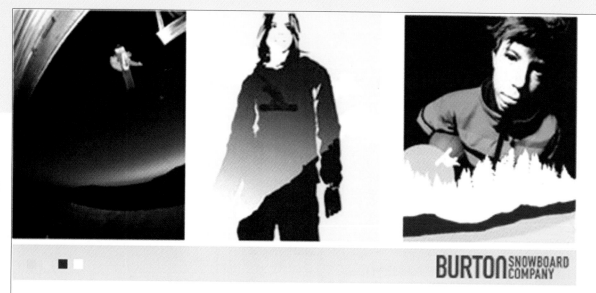

BURTON SNOWBOARD COMPANY

Select your language

English ▲▼

ENTER

2001 SITE STATUS <ACTIVE>

Fat pipe:
We're completely out of bounds this year so we recommend you have at least a 56k modem.

Go big:
Our site is big because it delivers more information for riders that crave tech. Your resolution must be at least 800 x 600 but the site is best viewed at 1024 x 768.

right: The most striking element of the Burton.com home page is its horizontally scrolling navigation bar. The motion instantly creates a focal point for the page and gives the site a dynamic feel. When the user rolls the mouse over the navigation bar, the horizontal motion pauses, allowing the user to easily make a selection.

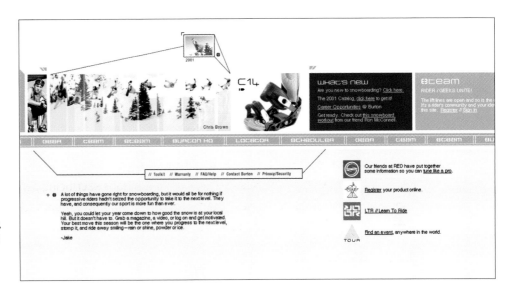

Workshop

Burton.com is the online home of Burton Snowboards, the Burlington, Vermont–based retail manufacturer of snowboarding gear and clothing.

What Works

Burton.com requires users to have the Flash Player, QuickTime, and Acrobat Reader installed to support the site's technology. The possibility of losing potential users was weighed against the advantages of pioneering a technologically charged site unlike anything seen before on the Web. "At Burton, we love to embrace technology," says Chuck White. "We approached building our website the same way we approach building a snowboard—we want to push ourselves as far as we can. It'll take a faster connection to view the site optimally, but the payoff is worth it." The advanced technology allows a richer user experience, featuring sophisticated animation, interactive elements, and streaming video.

The navigation bar scrolls horizontally across the center of the screen on the home page, immediately attracting the visitor's eye and creating a sense of motion. To navigate to the different parts of the site, the user selects an option from the navigation bar. When a cursor passes over the bar, the motion slows and the item is highlighted, allowing the user to make a selection. From here, each section takes over the page, and the navigation bar steps aside, moving to the left edge of the screen so that visitors can see an uninterrupted page.

Work Wisdom

Although the site does push technology, its designers know not to push it too far. "Because some visitors have slower connections, we've designed our navigation bar to get you to any specific page in a maximum of five clicks, usually less," says White. By condensing the information into fewer pages, the site enables the visitor to have a rich experience on each page without having to click around on dense, slow-downloading pages to get more information.

Pages on secondary levels borrow their design structure from the home page's horizontally scrolling navigation bar. "All of our pages are split into halves or thirds, built as small, even components that create the whole," says White. "This is also how we hide information until someone is ready for it. For example, on a snowboard page, we display the necessary background information to explain a certain model. If you click on one of these buttons, the page shifts to a deeper level of information. The benefit of this is that users aren't overwhelmed by information they aren't looking for."

above and right: While the site's calling card is its sophisticated design, Burton.com doesn't neglect to provide basic information such as a calendar of events and the locations of Burton retailers. These details prove to be just as essential to the success of this site as the design. Note how the navigation collapses into the left side of the page on the secondary pages.

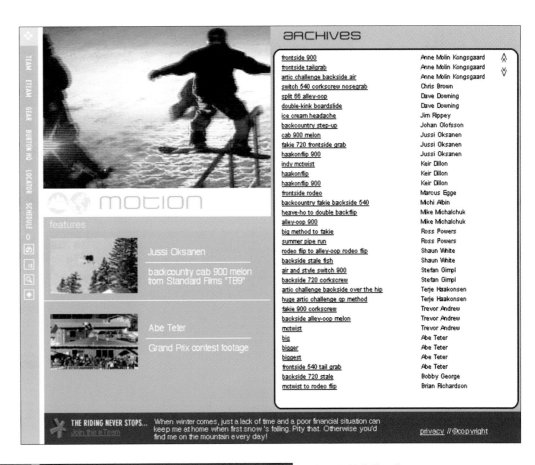

 archives

frontside 900	Anne Molin Kongsgaard
frontside tailgrab	Anne Molin Kongsgaard
artic challenge backside air	Anne Molin Kongsgaard
switch 540 corkscrew nosegrab	Chris Brown
split 66 alley-oop	Dave Downing
double-kink boardslide	Dave Downing
ice cream headache	Jim Rippey
backcountry step-up	Johan Olofsson
cab 900 melon	Jussi Oksanen
fakie 720 frontside grab	Jussi Oksanen
haakonflip 900	Jussi Oksanen
indy motwist	Keir Dillon
haakonflip	Keir Dillon
haakonflip 900	Keir Dillon
frontside rodeo	Marcus Egge
backcountry fakie backside 540	Michi Albin
heave-ho to double backflip	Mike Michalchuk
alley-oop 900	Mike Michalchuk
big method to fakie	Ross Powers
summer pipe run	Ross Powers
rodeo flip to alley-oop rodeo flip	Shaun White
backside stale fish	Shaun White
air and style switch 900	Stefan Gimpl
backside 720 corkscrew	Stefan Gimpl
artic challenge backside over the hip	Terje Haakonsen
huge artic challenge gp method	Terje Haakonsen
fakie 900 corkscrew	Trevor Andrew
backside alley-oop melon	Trevor Andrew
motwist	Trevor Andrew
big	Abe Teter
bigger	Abe Teter
biggest	Abe Teter
frontside 540 tail grab	Abe Teter
backside 720 stale	Bobby George
motwist to rodeo flip	Brian Richardson

motion

features

Jussi Oksanen
backcountry cab 900 melon from Standard Films "TB9"

Abe Teter
Grand Prix contest footage

✱ THE RIDING NEVER STOPS... When winter comes, just a lack of time and a poor financial situation can keep me at home when first snow 's falling. Pity that. Otherwise you'd find me on the mountain every day!
Join the eTeam

privacy // @copyright

INTRODUCTION

8.30.00
Department E

You are now viewing the INTELLIGENCE section of the Burton Snowboards 2001 site. Over the course of the upcoming season, this section will be your source to find out information about the Burton team...what contests they were in and how they did, what road trips they are causing havoc on, where they might be showing up soon...basically anything team related, this is the place to get the skinny.

Check back often...new stuff will be showing up all the time. Just click on whatever you want to read on the left and enjoy. Technology is a good thing.

intelligence

article	date submitted
Okemo U.S. Snowboaring Grand Prix	12/21/00
FIS Mt. Ste. Anne, Quebec	12/20/00
MOTOROLA ISF TOUR - BOARDERCROSS AT SOLDEN	12/20/00
MOTOROLA ISF TOUR - PGS AT SOLDEN	12/20/00
Burton Demo Tour @ Hunterfest	12/20/00
Breckenridge Vans Triple Crown	12/20/00
2000 Air & Style Results	12/20/00

✱ THE RIDING NEVER STOPS... Because it's an obsession
Join the eTeam

privacy // @copyright

above and left: The site goes beyond e-commerce by incorporating QuickTime movies, articles, and photographs about the sport and well-known riders. Through technology, Burton.com is able to bring its visitors closer to snowboarding itself and give riders inspiration by introducing them to some of the sport's most famous enthusiasts.

right and opposite: A high-tech way Burton.com suggests items that fit the visitor's needs is through the Robot. This interactive element provides information about Burton's products in a clever, engaging way.

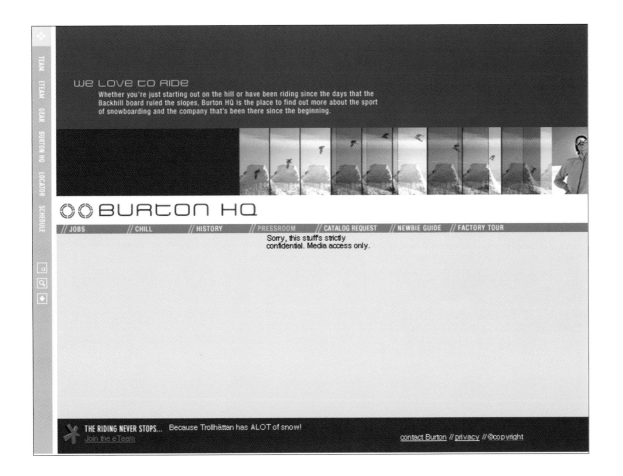

we Love to RIDe

Whether you're just starting out on the hill or have been riding since the days that the Backhill board ruled the slopes, Burton HQ is the place to find out more about the sport of snowboarding and the company that's been there since the beginning.

OO BURTON HQ

// JOBS // CHILL // HISTORY // PRESSROOM // CATALOG REQUEST // NEWBIE GUIDE // FACTORY TOUR

Sorry, this stuff's strictly confidential. Media access only.

THE RIDING NEVER STOPS... Because Trollhättan has ALOT of snow!
Join the eTeam

contact Burton // privacy // ©copyright

above: It was essential for the site to be more than just a reproduction of the company catalog. In the Burton HQ section, visitors can learn more about the history of the company, take a virtual factory tour, and research jobs.

right: Each of the site is different subsections have their own introductory page which orients the user to the various information found in the given section, and provides hints for accessing additional information.

bindings

FREESOLE® INTERFACE FEEL ▶▶

A feeling of comfortable freedom, with room to roll your foot, flex your sole, yet with progressive resistance anywhere you want immediate response. Ultimate binding feel is when you communicate so directly with your board that it reacts with your thoughts.

**"Strap" is inaccurate (many step-in boots have straps) and "conventional" is an understatement (none of our FreeSole Bindings are conventional).

SOLE CONTROL® INTERFACE FEEL ▶▶

The only step-in that feels like snowboarding. SI engagement secures the sole for instant torque and leverage. Skyback on the binding lets your upper boot flex freely. The feel of power without pressure, the feel of your energy flowing directly into the snow with all-day comfort.

*Rather than try to convince you that SI is the same as FreeSole—we'll demonstrate that for many riders, it's actually better: faster response when riding, faster in and out, plus comfort, feel, and dependability.

What size binding do i need?

cHoose an interface

THE RIDING NEVER STOPS... cause it keeps you focused....on the mountain!
Join the eTeam

contact Burton // privacy // ©copyright

NEW RUDY BEANIE

ASSORTED ▲▼

IN STORES ONLY

+ // SUPERSIZE

TECH.

MNS. // WMS. // YTH.

KNITS
>fleece
>
bucket head
sport wool beanie
tech radar
zig zag earflap
cable beanie
chenille beanie
cuff pompon
popcorn beanie
screened pompon
thin rib beanie
victorias angora
wide rib
color block beanie
new rudy beanie
shear warmth
beanie
sckullcap beanie
vertical rib beanie
woven cable
beanie

LIFESTYLE GO DEEP TEAM

Victoria

headwear

TEAM ETEAM GEAR BURTON HQ LOCATOR SCHEDULE

THE RIDING NEVER STOPS... beacus it just dumped on 'your local hill'
Join the eTeam

privacy // copyright

above and opposite: Visitors can access the entire Burton catalog online, learning more about the company's product line (which has evolved beyond snow-boards) and placing secure orders. Design and technology bridge the gap between the store and the site, allowing visitors to easily find and order the items they want or just browse through the entire Burton product line.

TEAM

ETEAM

GEAR

BURTON HQ

LOCATOR

SCHEDULE

0

KNITS

NEW RUDY BEANIE

A diverse group of headwarmers. We'll tell you about one. The Sport Wool Beanie is a Teflon®-coated wool hat for super water-repellency combined with the warmth of wool. Inside is a poly headband to wick away moisture and eliminate itching. Hard to believe we could cram so much tech into a beanie, but that's the way we are.

FLEECE

THE RIDING NEVER STOPS... What else would we do?
Join the eTeam

privacy //@copyright

WEBVAN.COM

CHANGING THE SHOPPING EXPERIENCE

Although online commerce sites are designed to simplify the shopping process, they also face formidable challenges. While technology brings obvious advantages in terms of quick product searches and the ease of processing transactions, commerce sites must compensate for the fact that they can't provide customers with the ability to actually see and touch the products they are buying. Not to mention, the concept of online transactions is still rather new—these sites must buck a lifetime of shopping habits and encourage consumers to try something different. Webvan uses its site's structure and technology to bring customers close to the items they are shopping for, while structuring the site in a user-friendly way that makes navigation and ordering easy.

right: Webvan has positioned itself as an online shopping hub. What started as an online grocery store has blossomed into a source for electronics, drugstore items, books, CDs, and more. The home page greets past customers, calls attention to special offers, and organizes steadily growing categories of information within the site.

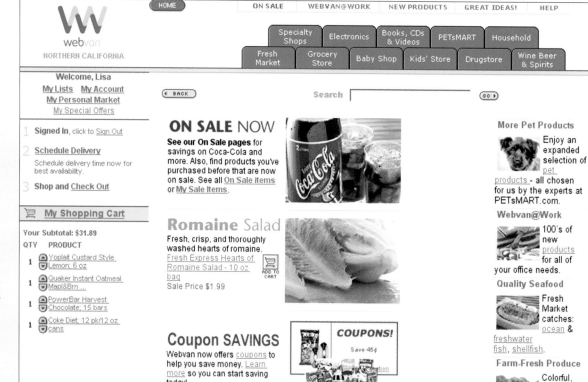

Workshop

Webvan.com is a Foster City, California–based online retailer—the company's in-house design department is responsible for the design and maintenance of the site.

What Works

The key to a successful commerce site like Webvan is a powerful, diversified search function to help visitors easily navigate through the thousands of items. Consequently, site designers didn't adapt a one-size-fits-all approach to search—the site's structure is designed to anticipate and facilitate the different ways people search online.

Visitors who know exactly what they want can access a direct product match (for instance, typing Skippy Peanut Butter takes you right to it). The search function is designed to provide approximate returns for misspelled words, increasing the opportunity for successful searches and eliminating off-putting "no items

found" returns. The site was also designed to accommodate the familiar act of browsing the supermarket aisles—visitors can skim through different categories by drilling down through the hierarchy of links. Pull-down menus allow visitors to quickly sort results by different criteria (including relevance, price, or such categories as organic or kosher). And different minishops within the site help visitors find a variety of items from one niche all in one place. For instance, in the Kids & Baby ministore, you can find everything from school supplies to lunchbox items.

"With our minishops we've made it much easier to shop, because everything is organized together," says Amy Nobile, Webvan's manager of public affairs. "This is something that's impossible to do in a brick-and-mortar store—to make it as easy to find peanut butter and cereal as it is to find kids' music and videos."

Work Wisdom

Sophisticated database technology is used to help users place orders even faster. The My Personal Market section remembers all the items visitors have placed in past orders, linking directly to them. Specifically, this section includes links to frequently purchased items, the last items purchased, all past purchases, and past purchases that are now on sale. Visitors can also create and save shopping lists that allow customers quick access to specific items. This feature helps visitors blaze through their shopping lists on subsequent visits, without having to hunt for items.

"We wanted the site to be as multidimensional as possible," says Nobile. "With the Personal Market, you've got your entire history of Webvan purchases right in front of you. Plus, anything you've ever ordered that is currently on sale pops up. It's incredibly consumer-friendly."

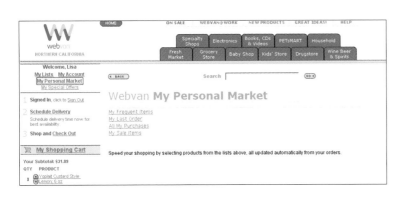

above and right: The site's back-end structure, powered by ASP and C++, is used to make the shopping experience faster and more efficient. The site remembers all items ordered by customers and provides links to these items organized into a few different lists, including frequent items and past purchases that are now on sale. Adding these items to the shopping cart takes a single click.

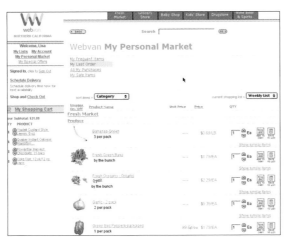

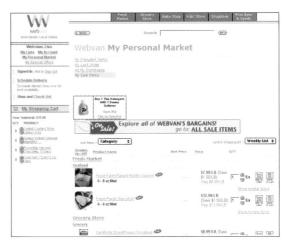

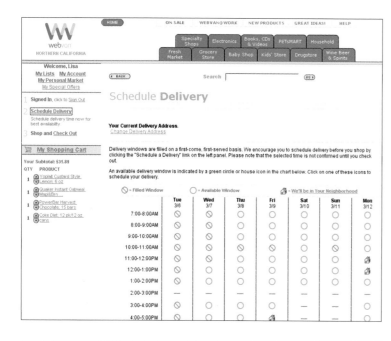

left: When placing an order, the visitor must schedule a one-hour window for the delivery. By including the schedule on one page, Webvan makes a week's worth of times available at a glance.

below: The same technology that remembers past orders allows Webvan shoppers to create personalized shopping lists. The lists are saved and can be accessed any time the visitor returns.

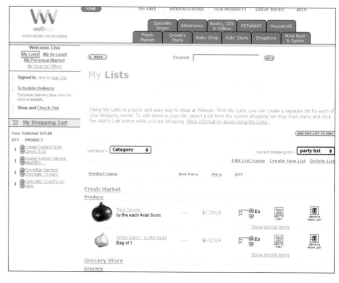

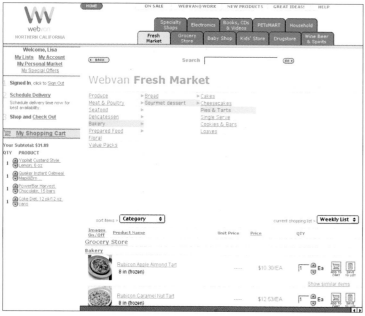

above: One of the traditional shopping experiences that the Webvan site approximates is the ability for users to browse the store's aisles. By clicking through different categories that provide virtual store aisles, visitors can be as specific or as broad as they wish.

right: With the volume of items included on the site, it's crucial to make it easy to sort through the different results for each search. Users can sort a list of returns by criteria that include category, price, new, on sale, kosher, and organic.

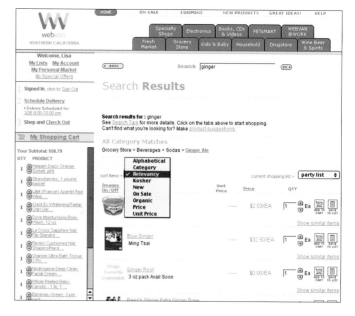

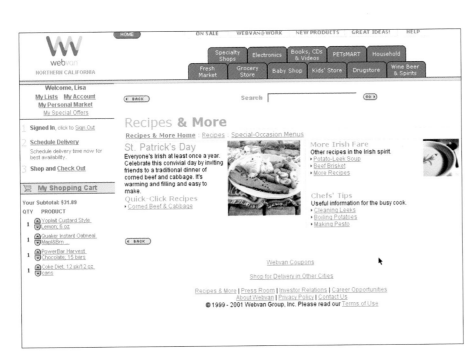

above: A crucial element in Webvan's success was providing easy access to help so visitors didn't feel that they were completely on their own. A Help link immediately connects users with answers to common questions, opportunities to see suggested products, and a customer-service area.

left: Although the site's interface guides users swiftly through different portions of the site, the site also positions itself as a destination where food lovers can get recipes, weekly menus, and more. Of course, recipe ingredients can be added directly to the user's shopping cart.

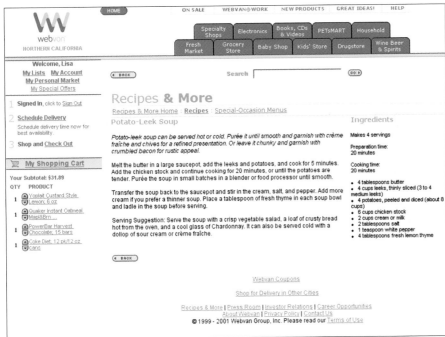

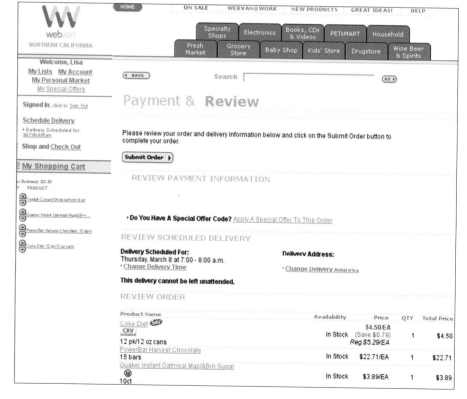

above: In order to both encourage repeat customers and allow users control over their own accounts, it was essential for Webvan to provide easy access to user account information, including links to details about past orders.

right: The shopping cart is always visible in the left column of the page, and a visitor can easily update the cart by summoning it to the main part of the page.

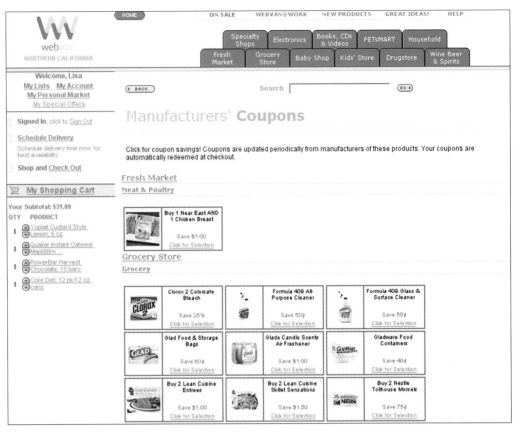

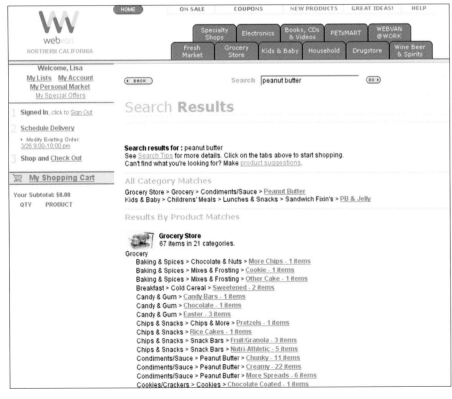

above: Webvan needed to incorporate some of the popular elements of super-market shopping into the site design when possible. Offering virtual manufac-turer coupons is one of the ways this is done.

left: A general search for an item such as peanut butter provides the user with a variety of options to narrow the search. Products are suggested both by category and by product name in a scrolling window. The navigation elements stay put, with the general site category tabs anchored at the top and links to account settings, delivery informa-tion, and checkout in the left column.

the familiar, not intuitive, interface

It is often said that the best interface designs are intuitive and natural. In his book, *The Human Interface,* Jef Raskin explains that intuitive interfaces simply do not exist. "When users say that an interface is intuitive, they mean that it operates just like some other software or method with which they are familiar," Raskin writes.

Web-usability guru Jakob Nielsen, derives his first "Law of the Internet User Experience" from the same cloth: "Users spend most of their time on other sites. This means that users prefer your site to work the same way as all the other sites they already know."

Thus, the best interfaces on the Web operate in ways that are familiar to us. If an interface is familiar, then there is nothing new to learn and we can seamlessly go about achieving the task at hand. The more your site follows design conventions and standards, typically the easier it will be to use. The best example of this is the shopping cart. For years, companies tried and failed at using other metaphors for the cart. One clever outdoor products company tried the shopping sled. No one understood it. They changed to the cart and revenues took off.

Following design conventions and standards does not necessarily mean sacrificing your website's unique appearance. It is only relevant that the site works in a manner that can be logically expected. The interaction and response we get from control elements should be predictable. Imagine if the number pad on every phone worked differently. The behavior of your site's navigation should be understandable, consistent, and persistent. This is why TV remote controls are so frustrating. Each one has different controls, labeled differently, in different locations.

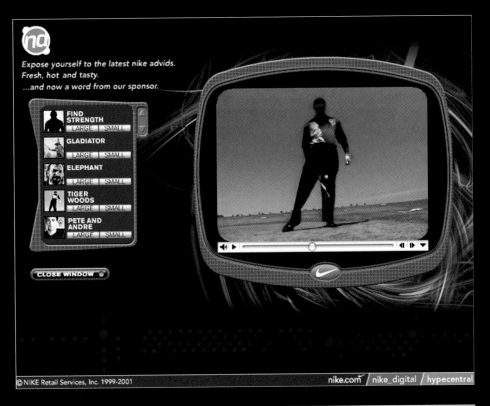

Expose yourself to the latest nike advids.
Fresh, hot and tasty.
...and now a word from our sponsor.

FIND STRENGTH
LARGE | SMALL

GLADIATOR
LARGE | SMALL

ELEPHANT
LARGE | SMALL

TIGER WOODS
LARGE | SMALL

PETE AND ANDRE
LARGE | SMALL

CLOSE WINDOW

© NIKE Retail Services, Inc. 1999-2001

nike.com / nike_digital / hypecentral

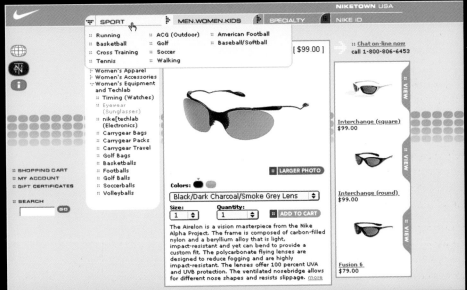

CONTENT

10"DOWNTOWN

The Web's timeliness and convenience have made it one of the first places people turn to read their news and find entertainment, giving newspapers, magazines, and even TV competition. Smart publishers of all media have responded by adapting existing content to the Web, creating an influx of content-focused sites. But a common mistake is to base the structure of these sites on print publishing models. Web publishing is a whole new ballgame, with a different way of interacting with its audience—and vice versa. The sites in this chapter have taken unique and thoughtful approaches to presenting information through the Web medium.

Take, for instance, Esquire.com, the online arm of *Esquire* magazine, a popular and established men's magazine. Branching off from the magazine with a new site wasn't a no-brainer. While the site serves as an extension of the magazine, it's also a destination all its own, with information and images optimized for the Web experience.

Considering that adult sites are the most popular genre on the Web, one cursory jaunt through some of these choice destinations makes it clear that most are getting by on their "assets." Nerve.com shows that you don't have to be sleazy to be sexy—it's a sophisticated, smart site that redeems this much-maligned niche.

And the Web brings visitors delicious alternative ways to discover, explore, and browse information. Smart sites exploit the nonlinear structure of the Web to deliver targeted information. ArtandCulture.com developed a fluid navigational structure of interrelated, floating words. Not only is the result lovely, but it's easy to use because it captures the ephemeral way people's thoughts fade in and out of their heads.

It will come as a surprise to many designers that it's entirely possible to evoke the beauty and texture of photographs and artwork through the Web medium. With careful optimization, images will translate well online and bring an often-neglected dimension to their subject matter. For inspiration, look no further than Do you remember, when, an online exhibit presented by the United States Holocaust Memorial Museum. The site's centerpiece is a beautiful personal journal that site designers lovingly depict in great detail. The pages of the site unfold from there.

What about sites for the professional designer? It doesn't get much better than Kaliber 10,000 (K10k), a design-related site run by two clever, talented, and opinionated London-based designers. Playing to the audience is half the battle, and this site allows visitors to rate the weekly features, post their own desktop images and appreciate the witty, uncensored banter of the site custodians and featured guests.

CHEAT SHEET:

Navigation: Should be intuitive but understated, allowing the content to take center stage.

Aesthetics: Gauged by the personality of the site—adapt the design to suit the content, but not overwhelm it.

Search: Again, intuitive, but understated.

Cutting-Edge Potential: Most of the site's content should be accessible by 90 percent of the audience, but opportunity for creating optional multimedia modules allows visitors the choice of accessing more sophisticated pages.

Copy Style: Good writing is at the heart of content sites—but keep the copy brief for the online audience. The same copy won't fly online that will in print.

DO YOU REMEMBER, WHEN

A TACTILE WEB EXPERIENCE

Just because the Web is a low-resolution digital medium doesn't mean that the palpable beauty of physical objects has to be lost. The nature of digital design assumes a pixel-oriented approach, but the screen is entirely capable of communicating the textures and tactile nature of images as effectively online as in print. Reproducing elements in high detail on-screen gives users a much more emotional connection to the content, a quality that makes "Do you remember, when," an online exhibition at the website of the United States Holocaust Memorial Museum, extremely effective.

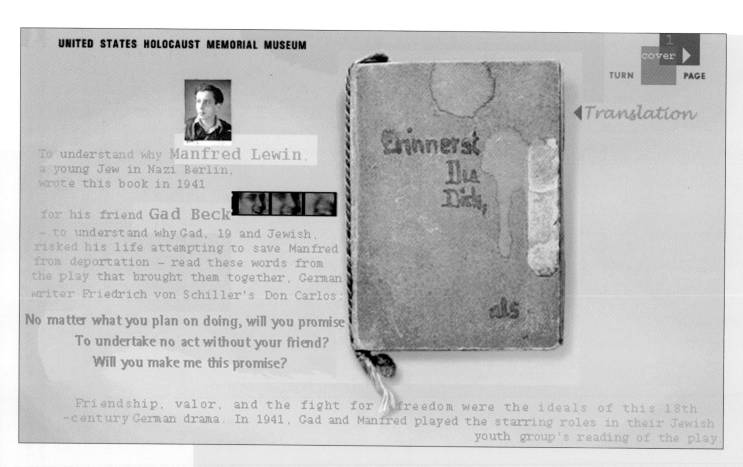

UNITED STATES HOLOCAUST MEMORIAL MUSEUM

1
cover ▶

TURN PAGE

◀ Translation

To understand why Manfred Lewin,
a young Jew in Nazi Berlin,
wrote this book in 1941

for his friend Gad Beck
— to understand why Gad, 19 and Jewish,
risked his life attempting to save Manfred
from deportation — read these words from
the play that brought them together, German
writer Friedrich von Schiller's Don Carlos:

No matter what you plan on doing, will you promise
 To undertake no act without your friend?
 Will you make me this promise?

Friendship, valor, and the fight for freedom were the ideals of this 18th
-century German drama. In 1941, Gad and Manfred played the starring roles in their Jewish
youth group's reading of the play

Workshop

The Outreach Technology Department of the U.S. Holocaust Memorial Museum is located in Washington, D.C.

What Works

"Do you remember, when" tells the story of Manfred Lewin, a young Jewish man who was active in one of Berlin's Zionist youth groups until his deportation to and murder in Auschwitz-Birkenau. The site is constructed around one haunting piece—a small, handmade book in which Lewin chronicled his story. Before his death, Lewin gave the book to his friend and gay companion, Gad Beck. To evoke the presence of the journal through the site, the navigation uses a booklike structure. Instead of making the minisite a hierarchical tree of information, the story unfolds through a series of pages, and the user advances through them page by page.

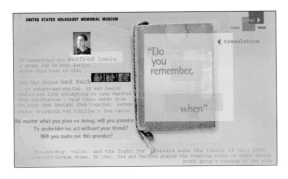

"Displaying the little book online provided a fabulous way to show it," says Adele Medina O'Dowd, creative director of online projects. "No one would really be able to touch or leaf through it in a museum setting. But in an online exhibition, we could enable an intimate and somewhat physical relationship by bringing the little book close to a viewer's face and allowing one to move at their own pace as you would with a book in your hands."

Work Wisdom

In order for the exhibition's design to be successful, it had to evoke the heart and soul of Lewin's handwritten pages. "The challenges lay in the technical aspects of making each page true to life," says Medina O'Dowd. "Our team (six in total to produce and construct this site) was very particular about lighting and shadows in the photography of the artifact. We debated about options for showing how a page turned and opted, not for animation which could slow the viewers' progress, but instead, for a spare method of navigation and therefore a more effortless experience."

The trick was using the Web to bring the visitor closer to the story and its corresponding artifacts. The designers opted to give a voice—literally—to Gad Beck, including links to audio interviews from different points in the site. Some pages were faithfully reproduced from the book, while other pages linked to information about the cultural zeitgeist of the time. "So [some] aspects of the website needed to look hand-constructed and occasionally unresolved, while others needed to look fresher," says Medina O'Dowd. "Gad Beck, a survivor today brimming over with memories, is depicted in motion as vivacious and even agitated. Other personal photos and effects used in the exhibition were portrayed in the light of found nostalgia."

opposite and this page: When visitors click on the link for the "Do you remember, when" exhibition, a new window immediately opens, launching the story. The centerpiece of the site is an image of the journal kept by Manfred Lewin—reproduced precisely as it exists, a weathered, aged document, a stark contrast to the perfected images usually found online.

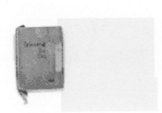

Introduction
What was it like to live as a young Jew in Berlin during the Nazi deportations? This exhibition details the life of Manfred Lewin, a young Jew who was active in one of Berlin's Zionist youth groups until his deportation to and murder in Auschwitz-Birkenau. Manfred

Manfred was born on September 8, 1922, in Berlin where he lived with his parents and four siblings in the predominantly Jewish section of the city. The family lived in poverty in three little rooms not far from the Beck house at Dragoner Strasse 43. Manfred's father was a barber and his mother Jenny, a former secretary, took care of the family. She often had to find other sources of food to supplement the family's insufficient Jewish food ration cards.

Gad was born on June 30, 1923 together with his twin sister Miriam. Gad's mother Hedwig came from a Protestant family, but converted to Judaism before the marriage with Heinrich Beck in 1920. The children were raised according to Jewish traditions, supported by the Christian relatives. In 1934 Gad changed to the Jewish school in the Grosse Hamburger Strasse. In 1938 his parents were forced to move into the predominantly Jewish section of Berlin. They could no longer afford the school fees, Gad started to work as an apprentice.

left: Links summon pop-up windows that provide detailed information on different points of the story. Here, visitors learn more about Manfred and Gad through text and archival photography.

Homosexual men were seen by the Nazis as a threat to their goal of a higher birthrate. The worldwide first gay and lesbian culture and its political, social and cultural institutions that had developed in the late twenties in Germany were destroyed immediately after Hitler's rise to power. Between 1933-45, about 100,000 men were arrested as homosexuals and half of them sentenced to prison of which an estimated 10,000 to 15,000 men were incarcerated in concentrations camps. They were marked with a pink triangle.

Only an estimated 1.400 to 1.750 Jews survived in hiding in Berlin. Without the help of non-Jews it would have been nearly impossible to obtain places to stay, food rations, and identification.

False ID certificates, like this one, and money were essential to survival underground. This ID card was used by

Jizchak Schwersenz.

above and left: The story uses contextual links to establish the tenor of the cultural and political atmosphere at the time. The links provide historical background and, in many cases, images from artifacts.

right: Audio clips from an interview with Gad add another dimension to the haunting story.

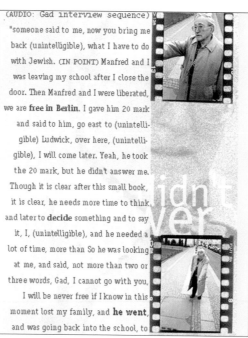

(AUDIO: Gad interview sequence) "someone said to me, now you bring me back (unintelligible), what I have to do with Jewish. (IN POINT) Manfred and I was leaving my school after I close the door. Then Manfred and I were liberated, we are **free in Berlin**. I gave him 20 mark and said to him, go east to (unintelligible) Ludwick, over here, (unintelligible), I will come later. Yeah, he took the 20 mark, but he didn't answer me. Though it is clear after this small book, it is clear, he needs more time to think, and later to **decide** something and to say it, I, (unintelligible), and he needed a lot of time, more than So he was looking at me, and said, not more than two or three words, Gad, I cannot go with you, I will be never free if I know in this moment lost my family, and **he went**, and was going back into the school, to

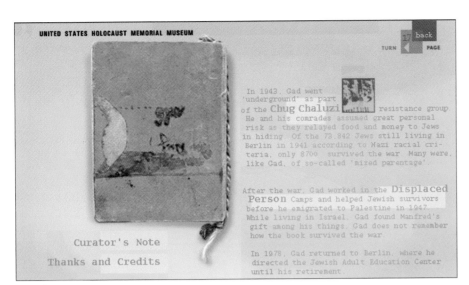

UNITED STATES HOLOCAUST MEMORIAL MUSEUM

TURN ◀ PAGE 17 back

In 1943, Gad went 'underground' as part of the **Chug Chaluzi** resistance group. He and his comrades assumed great personal risk as they relayed food and money to Jews in hiding. Of the 73,842 Jews still living in Berlin in 1941 according to Nazi racial criteria, only 8700 survived the war. Many were, like Gad, of so-called 'mixed parentage'.

After the war, Gad worked in the **Displaced Person** Camps and helped Jewish survivors before he emigrated to Palestine in 1947. While living in Israel, Gad found Manfred's gift among his things. Gad does not remember how the book survived the war.

In 1978, Gad returned to Berlin, where he directed the Jewish Adult Education Center until his retirement.

Curator's Note

Thanks and Credits

left: Staying true to its journal-like structure, the site has front and back "covers" that introduce the subject and summarize the story.

below: Original photography is a part of the site's design. Rather than trying to mend the images using photoediting software, the photographs portray their subjects in their aged glory, providing more insight into and intimacy with the subject matter.

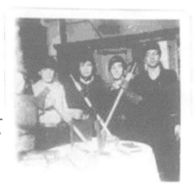

Jizchak Schwersenz, director of the **Jewish school at Choriner Strasse 74**, and three of his pupils carry helmets, tools, and books for their obligatory air raid patrol shift in early summer 1941. All public buildings in Berlin had to be patrolled. Gad and Manfred began their shifts in late summer 1941, after the school building had been evacuated due to bomb damage.

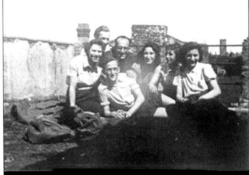

Manfred took this photo on the roof of Artillerie Strasse 14, where the Jewish school was relocated after the building at Choriner Strasse 74 was damaged by a bomb. Gad remembers: "We had packed food, sleeping bags, a guitar. It was the only alternative we had to a 'field trip,' since we were no longer allowed to go on outings outside of Berlin." He also remembers that he and Manfred fell in love during this outing. From left to right: Lotte Kaiser (who led the group), Schlomo Levin (Manfred's brother), (3)Jizchak Schwersenz (director of the Jewish School), with (4)Gad in the foreground.

By September 15, 1941, Jews in Germany were forced to wear a yellow star. The six-pointed yellow star (as big as a palm) had a black border and the inscription "Jude" (Jew). The star, which also represented a public stigmatization, was introduced to facilitate the identification of Jews in preparation for their deportation to the East.

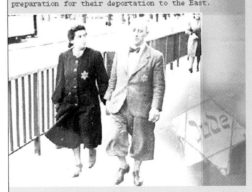

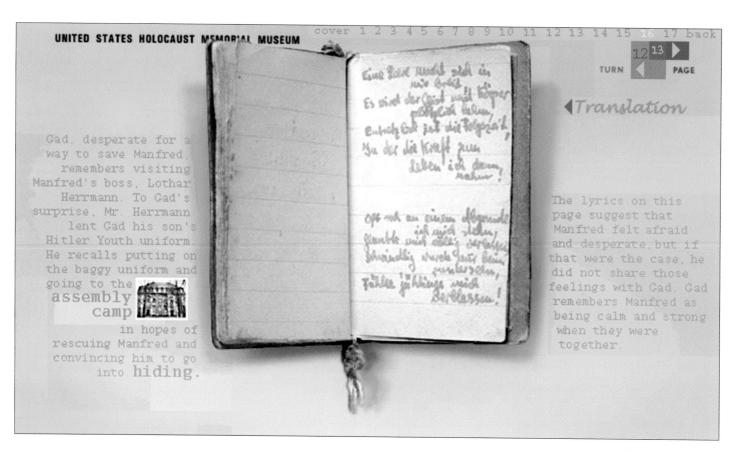

12 13 ▶
TURN ◀ PAGE

◀Translation

Gad, desperate for a way to save Manfred, remembers visiting Manfred's boss, Lothar Herrmann. To Gad's surprise, Mr. Herrmann lent Gad his son's Hitler Youth uniform. He recalls putting on the baggy uniform and going to the **assembly camp** in hopes of rescuing Manfred and convincing him to go into **hiding**.

The lyrics on this page suggest that Manfred felt afraid and desperate, but if that were the case, he did not share those feelings with Gad. Gad remembers Manfred as being calm and strong when they were together.

above: Rather than creating a hierarchical structure for the site, the designers chose to allow it to unfold in a linear way. The user pages through the site using the navigation in the upper right. This structure evokes the site's centerpiece, Lewin's journal.

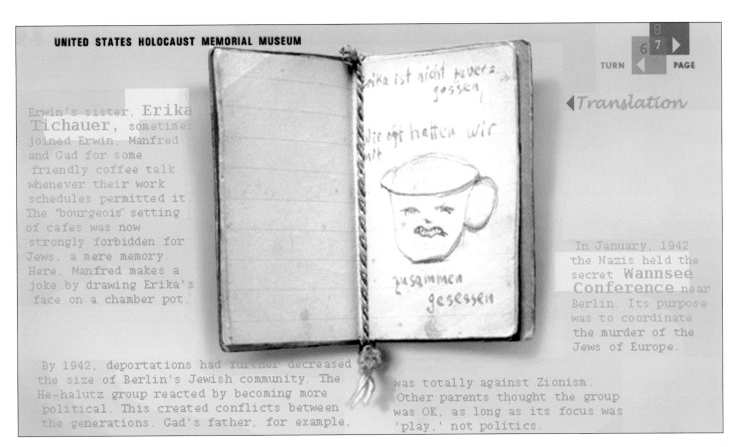

above: The journal is portrayed on every page, and opens to pages written in Lewin's own hand. Rollover graphics provide translations for the visitor.

ARTANDCULTURE.COM

BUSTING OUT OF THE HIERARCHY

When you consider exactly what it is that makes websites revolutionary, it all comes down to the hyperlink—the fact that a single mouse click can instantly propel users to an entirely different place. Although every site is built on a series of links, few sites really take advantage of hyperlinks' versatility, instead creating their sites to be navigated only using a traditional table-of-contents approach, with layers of hierarchical information. These sites could learn a thing or two from ArtandCulture.com, a site whose content is delightfully interconnected, where a click may lead visitors in a variety of different directions that they never anticipated.

right: From the home page, the visitor gets a sense both of the vast amount of information that's included on the site and of the navigation approach. This is where the site's unique floating navigation is introduced, along with links to each category and subcategory, simultaneously teasing the user with the enormous amount of information on the site and providing a variety of ways to search through that information.

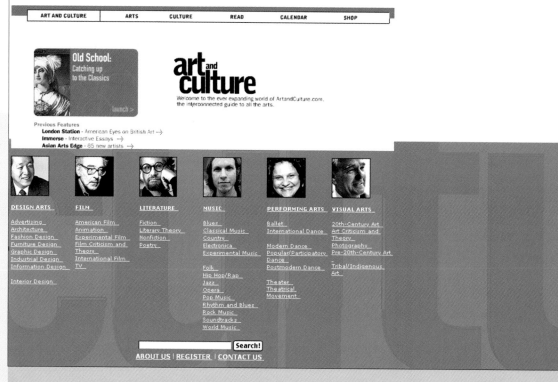

Workshop

Created by San Francisco–based marketing and media company PlanetLive, ArtandCulture.com is an immense site that acts as an encyclopedic resource about everything associated with the arts and artistic culture.

What Works

ArtandCulture.com is content rich, with hundreds of profiles on different artists, movements, and genres. Rather than honing in on a specific artistic specialty, the site is delightfully diversified, containing information on everything from fashion design to hip-hop to post-modern architecture. Although each principal category is organized hierarchically, a floating navigational menu suggests related content from the entire site. Below this, a separate element orients each feature geographically and chronologically with a timeline and a world map.

Visitors can search by keyword or browse through subject categories to locate the subjects, artists, or movements they're interested in. But what's interesting about each search is that it returns a series of associative links that reveal more information and the context for the topic. "We put the user in the position to read in different directions," says Marc Lafia, creative and editorial director at ArtandCulture.com. "The structure allows things to happen in exciting angles to one another. For each query, there is a different line of flight."

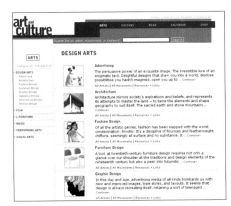

WORK WISDOM

Cross-linking and suggesting analogous information are what makes this site so effective. "Through the site-design process, we discovered that hierarchy is one way of looking at things," says Lafia. "But there are also connections to be across artists, disciplines, across genres. If you want to find something specifically, you can do that. But we also wanted the site design to be experiential; we wanted there to be an element of surprise and delight of pervasive associativeness that allows one to start at any point and arrive at any other."

above: For more information about a subcategory, visitors can simply go to the first page of each category. Additional links take visitors directly to a list of artists, related movements, resources, and links.

right: Information throughout the site is carefully organized and painstakingly cross linked. The wealth of information is further organized by enabling the visitor to sort within categories. For instance, visitors can search artists or movements alphabetically, geographically, or chronologically.

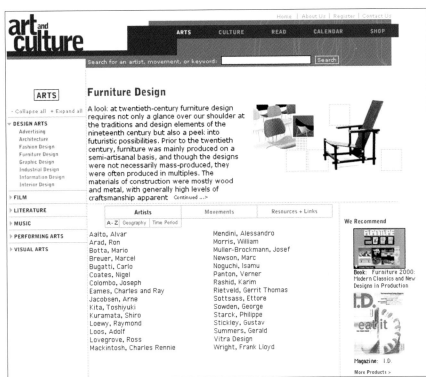

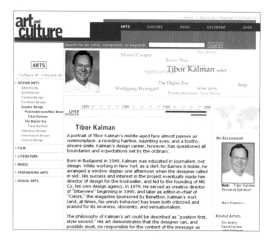

above: Every feature includes a written piece about the topic, a map, and a timeline. Related items are listed down the right-hand side of the page, while the floating navigation area in the top third of the screen pulls all of this related information together as one elements and provides a springboard to the next search.

right: One of the keys to ArtandCulture.com's success is that although the site is based largely on objective facts, subjective information enters into play as well. This search for Isaac Mizrahi returned a variety of keywords, including "quirky" and "sophisticated," that connect Mizrahi to such disparate figures as Matt Groening and Gertrude Stein.

below right: All of the site's content is supplemented with even more information about the hundreds of linked subjects. In the Culture section, visitors can learn more about the geographic locations referenced in the features by searching by region to locate information about everything from folklore to cuisine.

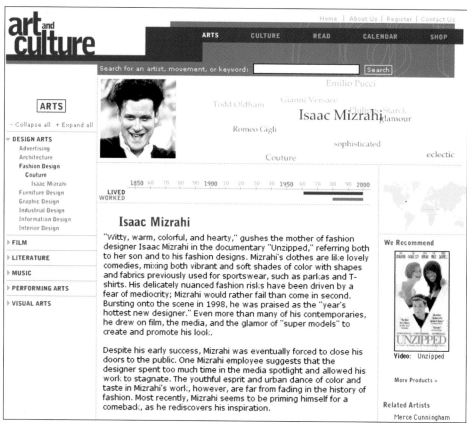

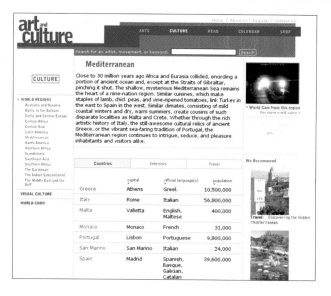

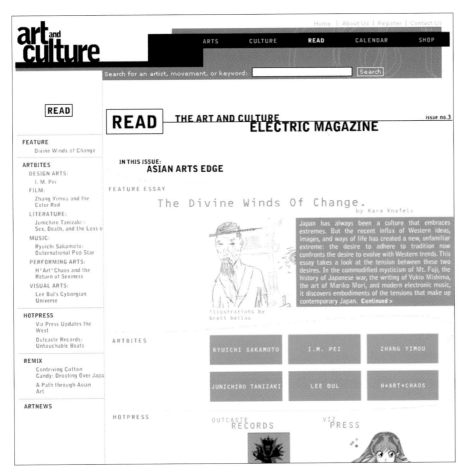

above: All of the nuggets of information in the site are integrated in *Read*, ArtandCulture.com's online magazine. This section gives the raw information context and adds another element of vibrant content to the site.

FEATURE

On art, artists, and the creative process(es).

Divine Winds of Change

by Kara Knafelc

The Kawaguchi Sex Museum sits at the foot of Mt. Fuji, Japan's most beloved -- and phallic -- icon. The figurines within represent either War or Love: one half of the museum displays the paraphernalia of the samurai, while the other exhibits carved figures once used to teach the privileged art of a good fuck. This odd little segue of an edifice, while it pays tribute to the highly romanticized Edo Period, also exemplifies the divided mind of the Japanese culture as a whole. This is a culture that has always been tolerant of extremes, even invested in them. The question is how the Japanese will embrace the whole new set of extremes ushered in by the monumental changes of Japan's recent history.

Mt. Fuji, once the site of religious pilgrimages, is a striking symbol of these changes. Besides the sex museum at its base, the mountain also boasts a vending machine at its gracious, 12,395-foot peak. This crowning glory, a Suntory soda machine, purveys Pocari Sweat and Oolong Tea with the precise rhythm of a slot machine. Japan's rigid economy of tradition seems to meet the new economy of commodity at this lofty point: just high enough to inspire altitude sickness, the summit of Mt. Fuji (an extinct volcano that last blew its top in 1707) feels like the apogee of a revolution, the cusp of a transformation. Its extremes are heralded by the ping-ping of coins dropping steadily into the machine, a unique tribute to the uberaccessibility of all things shiny and packaged.

ARTS

- Collapse all + Expand all

▽ DESIGN ARTS
Advertising
Architecture
Fashion Design
Furniture Design
Graphic Design
Industrial Design
• Information Design
Interior Design

▽ FILM
American Film
Animation
Experimental Film
Film Criticism and Theory
International Film
TV

▷ LITERATURE

▷ MUSIC

▷ PERFORMING ARTS

▷ VISUAL ARTS

above: Visitors can browse the site by using the navigation bar down the left side of the screen. This Flash-enabled tool allows visitors to see what information is available in each major category and easily navigate among areas.

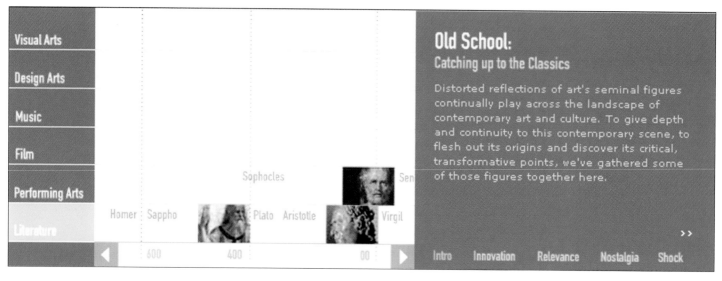

Old School:
Catching up to the Classics

Distorted reflections of art's seminal figures continually play across the landscape of contemporary art and culture. To give depth and continuity to this contemporary scene, to flesh out its origins and discover its critical, transformative points, we've gathered some of those figures together here.

Visual Arts

Design Arts

Music

Film

Performing Arts

Literature

Homer · Sappho · Sophocles · Plato · Aristotle · Virgil · Sen

600 400 00

Intro Innovation Relevance Nostalgia Shock

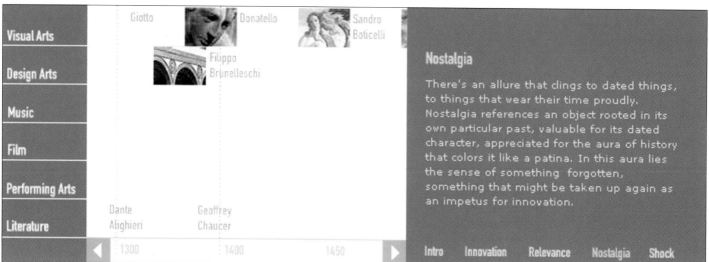

Giotto Donatello Sandro Boticelli

Filippo Brunelleschi

Visual Arts

Design Arts

Music

Film

Performing Arts

Literature

Nostalgia

There's an allure that clings to dated things, to things that wear their time proudly. Nostalgia references an object rooted in its own particular past, valuable for its dated character, appreciated for the aura of history that colors it like a patina. In this aura lies the sense of something forgotten, something that might be taken up again as an impetus for innovation.

Dante Alighieri Geoffrey Chaucer

1300 1400 1450

Intro Innovation Relevance Nostalgia Shock

above: The design of ArtandCulture.com provides a variety of ways to experience information on the site. This special feature is devoted to the old-school artistic pioneers, organized in an interactive timeline.

right: The site is constructed to be not only a static resource for artistic and culture information but also a dynamic destination that provides up-to-date information. The calendar includes information about upcoming events around the world.

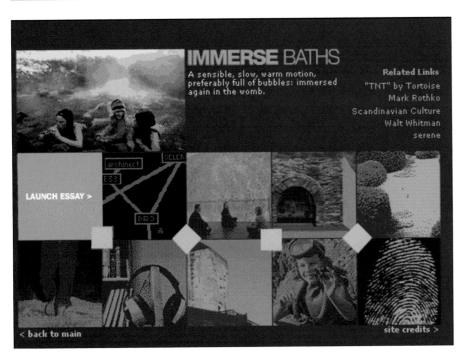

Welcome to IMMERSE.
Part one of a two-part multi-media investigation into the experience of immersion.

When someone becomes immersed in something, she achieves a state of profound involvement. Gardening, swimming in the ocean, playing video games, meditating: these motions absorb energy, pulling it into intense focus, swallowing it smoothly up -- but without digesting it. Because the Net itself is one of the all-time greatest immersive mediums, it's the perfect showcase for this overview on the experience of immersion. The use of rich, ambient media -- beguiling sounds, texts, videos, animations, interactive interfaces -- lets us sink our teeth into the Net, and it returns the favor.

Enter ⋯›

IMMERSE BATHS

A sensible, slow, warm motion, preferably full of bubbles: immersed again in the womb.

Related Links
"TNT" by Tortoise
Mark Rothko
Scandinavian Culture
Walt Whitman
serene

LAUNCH ESSAY >

‹ back to main site credits ›

H2O

left: Aside from the resource information, ArtandCulture.com sometimes uses experimental design elements as special features, adding another dimension to the site's scope. This feature is a multimedia investigation into the concept of immersion.

K10K.COM

DESIGN FOR DESIGNERS

It's hard to imagine a target Web audience more critical than the design community, especially when the site in question focuses on the graphic arts. But while you certainly can't please all the designers all the time, you can still create evocative content and design that breaks the rules and inspires intelligent discourse on the nature of art. But few websites do so. It was the dearth of originality and the reluctance of sites to take a stand on controversial issues—design or otherwise—that inspired the birth of Kaliber 10,000 (K10k).

right: The home page design uses a strong grid, effectively organizing the different features and sections of the site. The primitive illustrations stand out against the gray background and work well with the site's modular approach.

right and below: Each
week, K10k introduces a
new feature by a different
designer. In the spirit of the
site, anything goes.
Features have included
everything from interactive
Flash movies to written
musings on the nature of
design.

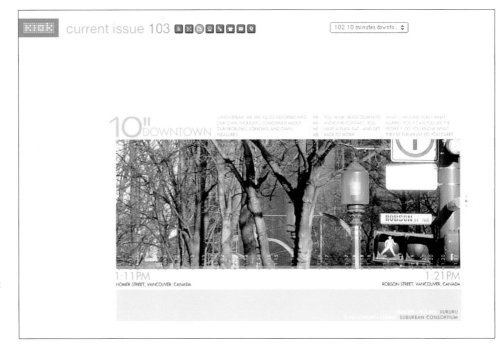

Workshop

K10k is a collaborative effort between Michael Schmidt
and Toke Nygaard, two London-based designers.

What Works

Rather than attempting to create a site with the flavor
of whatever contemporary style is au courant, the
designers kept the design basic, with a minimalist
grid-dominated approach and simple illustrations. But
the element that gives this site its soul is its irreverent,
provocative approach to the art and design. "The qual-
ity of content on most sites really varies," says Toke
Nygaard, one of the cofounders of K10k. "Many people
don't think creatively when designing online because
they think the Internet has to take a certain approach.
We were tired of the politically correct approach—we
don't censor the issues. With the site, we try to inspire
people to see things in a different way."

Knowing that virtually everyone in K10k's target audi-
ence would have a strong opinion about the design
and content features, site designers incorporated a
rating system into the site. The aggregate user ratings
on humor, smoothness, complexity, and innovation are
tabulated and featured prominently on the home page.

Work Wisdom

The News section in the upper-right corner of the home page includes an ongoing
dialogue between the K10k crew and special guests, well-known names in the
design community. Time-stamped news postings arrive from all over the world
hourly, providing the site with fresh content and visitors with a reason to visit the
site frequently. "Our news section is a great way of keeping the site fresh," Nygaard
says. "You don't have to go hunting to find new information. The news then
becomes more interactive, it creates discussions."

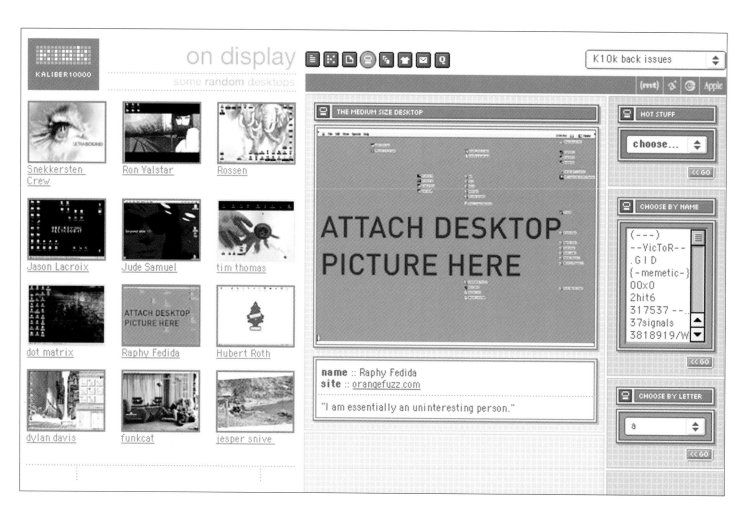

above: Site visitors' contributions are an integral part of the site's mission—to create discussion and collaboration on the nature of design. The ongoing On Display exhibition includes screen shots of designers' computer desktops from around the world.

right: The most dynamic part of the site is the News section, which includes short postings from the K10k crew and special guests—big names from the design community. Topics range from site recommendations to design-related rants. The spirited discussion that takes place here inspires visitors to return often to read new postings.

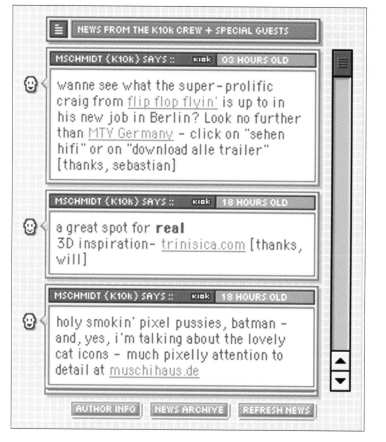

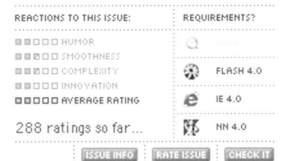

REACTIONS TO THIS ISSUE:	REQUIREMENTS?
▣▣□□□ HUMOR	◔ NONE
▣▣☑□□ SMOOTHNESS	❀ FLASH 4.0
▣▣☑□□ COMPLEXITY	
▣▣□□□ INNOVATION	𝒆 IE 4.0
▢▢▢▢▢ AVERAGE RATING	ℕ NN 4.0

288 ratings so far...

`ISSUE INFO` `RATE ISSUE` `CHECK IT`

left: Knowing that designers have opinions on everything—especially design-related websites—the site's designers give visitors an opportunity to rate each issue on a variety of criteria, including humor, complexity, smoothness, and innovation. The votes are tallied and displayed on the front page of the site.

below left: The voice of K10k users is incorporated at every opportunity on the site. When cofounder Michael Schmidt posted a long treatise on the state of contemporary design, he received a deluge of e-mail from people all over the world responding to his writing. The responses are compiled in the Rants + Raves section.

rants+ raves

CREDITS LIST ALL>>

THE K10k CREW + BARNEY THE BEAGLE PRESENTS : RANTS+RAVES

A couple of weeks ago mschmidt was kind of pissed off, kind of depressed, kind of bored with it all. He felt the need to rant a bit, to bitch & whine & try to get everything bad out of his system.

He decided to write a long post at K10k, complaning about the lack of decent content on today's leading edge design-sites, and the general "form over function"-mentality that seemed to prevail whereever he turned his eyes.

At the time, we had **no idea** how much reponse this posting would provoke and we quickly found ourselves deluged with some of the most interesting emails we've received in years.

So, with the aide of new corporate mascot, Barney the Beagle, we now have the pleasure of presenting **the rants+raves special feature** - an uncensored, unbiased look into the thoughts, ideas & feelings of everyone who responded.

Have fun,
mschmidt + token + per + barney

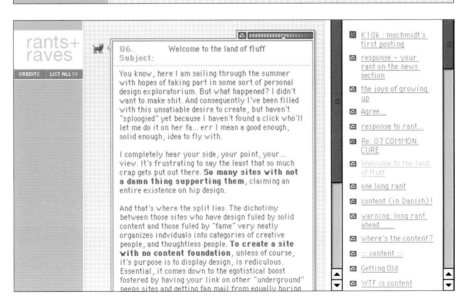

rants+ raves

CREDITS LIST ALL>>

06.
Subject: Welcome to the land of fluff

You know, here I am sailing through the summer with hopes of taking part in some sort of personal design exploratorium. But what happened? I didn't want to make shit. And consequently I've been filled with this unsatiable desire to create, but haven't "sploogied" yet because I haven't found a click who'll let me do it on her fa... err I mean a good enough, solid enough, idea to fly with.

I completely hear your side, your point, your... view. It's frustrating to say the least that so much crap gets put out there. **So many sites with not a damn thing supporting them**, claiming an entire existence on hip design.

And that's where the split lies. The dichotimy between those sites who have design fuled by solid content and those fuled by "fame" very neatly organizes indviduals into categories of creative people, and thoughtless people. **To create a site with no content foundation**, unless of course, it's purpose is to display design, is rediculous. Essential, it comes down to the egotistical boost fostered by having your link on other "underground" neens sites and getting fan mail from equally boring

- ✉ K10k : mschmidt's first posting
- ✉ response - your rant on the news section
- ✉ the joys of growing up
- ✉ Agree...
- ✉ response to rant...
- ✉ Re: 07 COMMON CURE
- ✉ Welcome to the land of fluff
- ✉ one long rant
- ✉ content (in Danish)!
- ✉ warning: long rant ahead......
- ✉ where's the content?
- ✉ ::: content :::
- ✉ Getting Old
- ✉ WTF is content

right: The Special Features
section of the site includes a
variety of intriguing work that
needs an audience. "Sometimes
people have some stuff for us
which does not fit the issue
format, and then we consider
putting it up as a special
feature," says Nygaard.

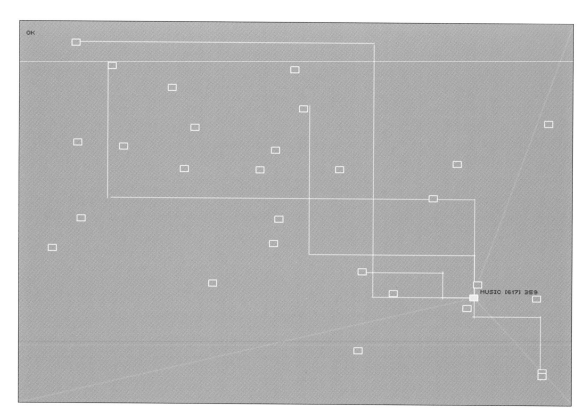

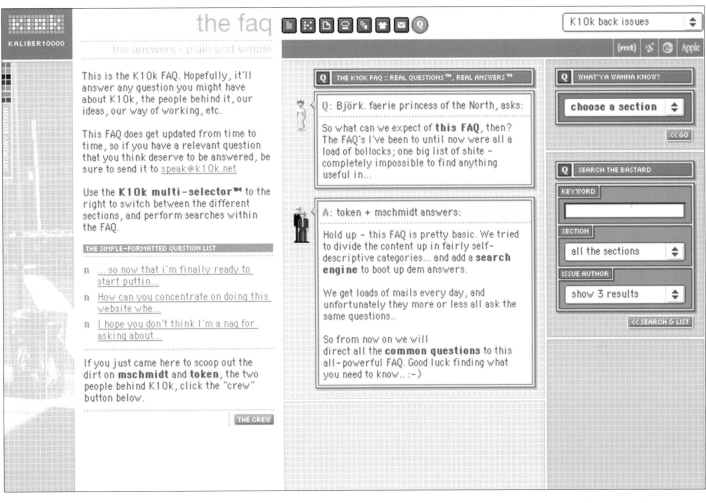

the faq
the answers - plain and simple

KALIBER10000

This is the K10k FAQ. Hopefully, it'll answer any question you might have about K10k, the people behind it, our ideas, our way of working, etc.

This FAQ does get updated from time to time, so if you have a relevant question that you think deserve to be answered, be sure to send it to speak@k10k.net

Use the **K10k multi-selector™** to the right to switch between the different sections, and perform searches within the FAQ.

THE SIMPLE-FORMATTED QUESTION LIST

n ... so now that i'm finally ready to start puttin...
n How can you concentrate on doing this website whe...
n I hope you don't think I'm a nag for asking about...

If you just came here to scoop out the dirt on **mschmidt** and **token**, the two people behind K10k, click the "crew" button below.

THE CREW

Q THE K10K FAQ :: REAL QUESTIONS™, REAL ANSWERS™

Q: Björk, faerie princess of the North, asks:

So what can we expect of **this FAQ**, then? The FAQ's I've been to until now were all a load of bollocks; one big list of shite - completely impossible to find anything useful in...

A: token + mschmidt answers:

Hold up - this FAQ is pretty basic. We tried to divide the content up in fairly self-descriptive categories... and add a **search engine** to boot up dem answers.

We get loads of mails every day, and unfortunately they more or less all ask the same questions..

So from now on we will direct all the **common questions** to this all-powerful FAQ. Good luck finding what you need to know.. :-)

K10k back issues

(mt) Apple

Q WHAT'YA WANNA KNOW?

choose a section

<< GO

Q SEARCH THE BASTARD

KEYWORD

SECTION

all the sections

ISSUE AUTHOR

show 3 results

<< SEARCH & LIST

above: No effective content site would be complete without a powerful search function. K10k is no exception, with a search box imploring users to Search the Bastard, allowing searches to be narrowed according to a variety of different criteria.

faster, faster, faster

The number one complaint about the Web is that it's too slow.

The cause of this problem is irrevelant to the users. They don't care if it's their

28.8 bps dialup connection, Internet congestion, or poor server throughput. They just

want to get in and get out, controlling the experience at their own pace. Usually that pace is fairly quick, and people

simply don't like to wait.

above opposite: While Nike.com's pages are fairly graphic-intensive, they have been optimized for speedy download. Nike also uses Akamai.com to help serve the images faster.

below opposite: In Nike's e-commerce environment, the number of graphics is scaled back to ensure a fast buying experience.

But having a fast website isn't just about providing convenience to the user. It has a tremendous effect on users' perception of content quality, product reliability, security, and the overall brand.

Think of it this way: You buy something at a store. The clerk is helpful, they have what you want in stock, and the ambience is even agreeable. Then you wait in line for thirty minutes at the store checkout. Regardless of its good aspects, this will now be remembered as an unpleasant experience. Speed is often valued as a critical component of determining the quality of service.

The same holds true online. Studies have shown that a page that loads quickly is deemed more interesting and relevant than the same page loading at a slower speed. Slow-downloading pages may make users think the system is unreliable, so they will not feel safe in giving your business their credit card information. If all the pages are slow on a site, the net effect is negative for the brand and its products. The user may never come back to the site.

The speed of your site should be a priority for frequent testing. While a growing percentage of users are adopting faster access connections, the bulk of the online audience is still using dial-up access. Testing shows tolerance levels range from two to ten seconds per page to download. But all evidence shows that faster is indeed better, so shoot for a target of four to five seconds per page. It could make a difference of hundreds of thousands of dollars to your bottom line.

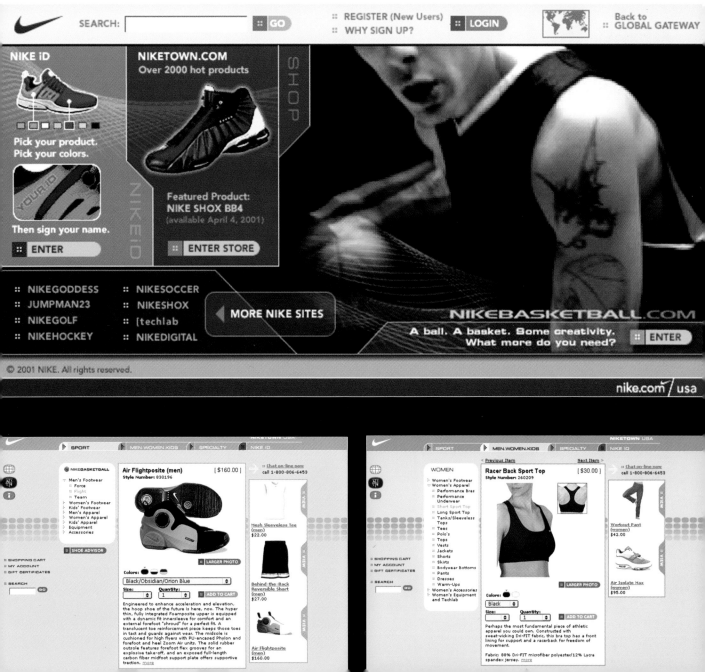

NERVE.COM

HOW TO "DO" ADULT CONTENT

The sites that are profiting on the Web aren't who you think they are. Adult-oriented sites consistently surpass every other Internet content genre when it comes to profitability. However, before Nerve.com debuted, this niche was plagued with poorly designed sites full of dull-witted content. With its fresh, sophisticated approach to sex and sexuality, Nerve has become a refuge for those who want a healthy dose of intelligent eroticism online.

right: Nerve's home page exists in stark contrast to other sites that feature erotic content. Missing are the egregious nudie shots–in their place, visitors find artistic black-and-white photography, a sophisticated color palette, and links to provocative writings on sex.

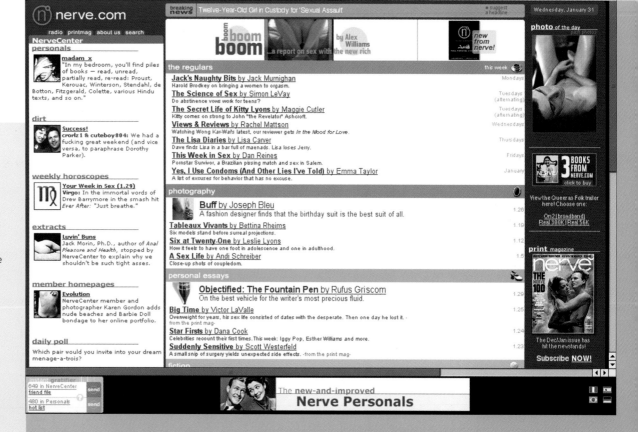

Workshop

Nerve.com is a New York City–based Website and print magazine dedicated to intelligent discourse on the subject of sex. As the site's creators say in their mission statement, "Nerve exists because sex is beautiful and absurd, remarkably fun, and reliably trauma inducing. In short, it is a subject in need of a fearless, intelligent forum for both genders."

What Works

Nerve's approach to design is a marked departure from that taken by other adult-oriented sites. "When we started talking about the look and feel of Nerve, we agreed that a warm, comfortable lounge with couches and velvet curtains was what we wanted to convey," says Joey Cavella, Nerve's creative director. "We wanted our readers to be relaxed and soothed by the overall feel of Nerve.com. Sexuality can be an uncomfortable subject for some people to think about, so we wanted the design to be as warm and loving as possible."

Eschewing the cartoonish icons popular on many sites, Nerve chose to implement antique-looking photographic icons to represent the different sections, conveying a sense of sophistication and realism. The cream and maroon color palette is more likely to be found as the decorating scheme for a living room than a website, evoking the parlor atmosphere Nerve designers hoped to achieve.

Work Wisdom

The intimate nature of the site's subject matter makes fostering a sense of community among site visitors essential to the site's mission. "Because Nerve is not stupid porn or flowery erotica, our readers take a more intelligent approach to thinking about sex," says Cavella. "Nerve readers have a common interest in thinking about sexuality and feeling free to discuss and explore the interest. Offering new ways for our readers to communicate with each other is key to our success."

Consequently, there are several different ways users can interact with one another. The NerveCenter is the hub for visitor interaction, featuring personals, message boards, chat, and more. Through the Nerve personals, visitors can create and browse provocative personal ads, often featuring artistic portraits and information about everything from a poster's favorite on-screen sex scene to the last great book he or she read. But it's the Instant Gratifier that really brings visitors together.

"The Instant Gratifier is a Web-based—no software to download—instant messenger for the Nerve community," Cavella says. "We placed a small console on every page of the site in the lower left corner that displays how many readers are logged into NerveCenter, how many are logged into Nerve Personals, and lets users know if they have any messages. From the console readers can find out who is currently online and send them messages that will appear in their console."

right: One of the ways the site keeps fresh is by teasing different daily features on the home page. The photo of the day showcases a different artistically erotic image each day.

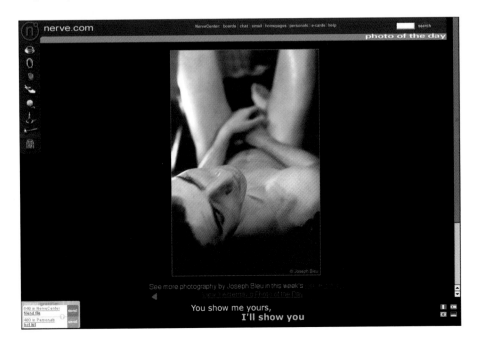

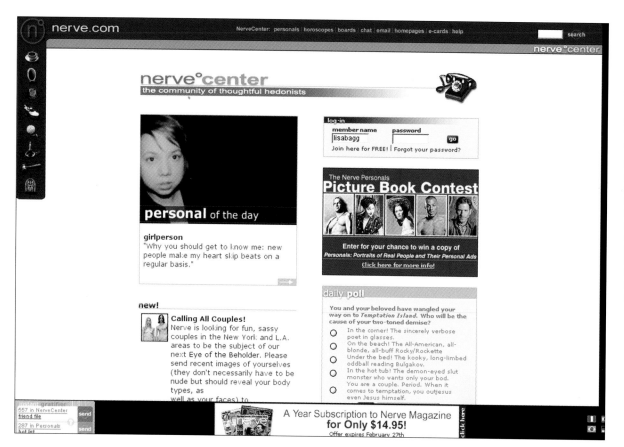

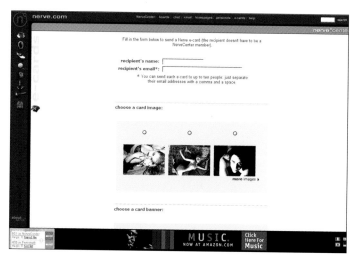

right: Regular contributors post new articles to the site weekly. Taking a cue from its print predecessors, Nerve creates a relationship between its visitors and contributors with regular correspondence.

below: Nerve designers created an innovative way to foster an ongoing dialogue among the site's visitors with the Instant Gratifier. This Web-based instant messenger allows logged-in users to communicate privately. A console in the lower left corner of the page enables visitors to see how many other members are currently logged in.

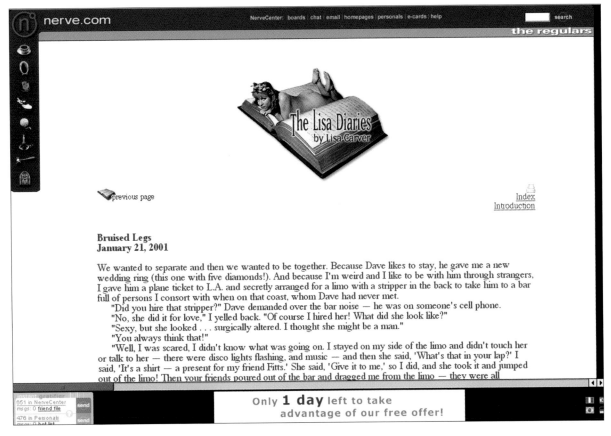

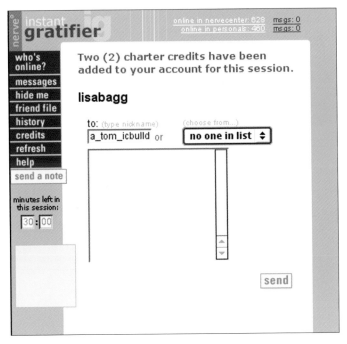

right and below: People can also experience the sound of Nerve. NerveRadio includes music and spoken word RealAudio downloads, adding another dimension to the site.

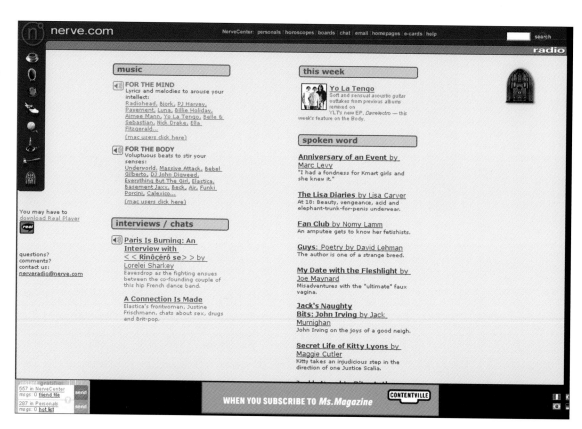

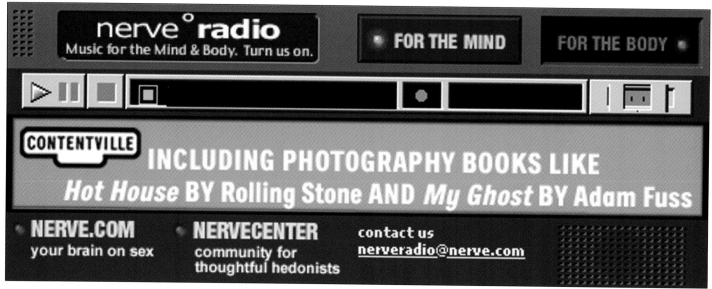

Sex for Sale!

Buy a Subscription to Nerve Magazine
for only **$14.95!**

Over 1/2 off
the cover price!

click here

Offer expires February 27th

**Sex for Sale: Buy a US or Canadian subscription to Nerve
Magazine before February 27th, and pay only $14.95!**

Get six issues of smart writing on sex and cutting edge photography in
Nerve's glossy, high-quality bimonthly magazine for $14.95 — **that's
over half off the cover price!** Take advantage of this offer before it
ends on February 27th and you'll kick off your subscription with the
fourth issue, which includes photography by Todd Oldham, a personal
essay on love and weight loss by Victor LaValle, and a report on the
sexual mergers and aquisitions of the newly rich by Alex Williams, plus
new fiction by Matthew Klam.

If you'd like to take advantage of this limited time offer and subscribe now, your first dirt cheap issue
will arrive within four to six weeks. For instant gratification, Nerve is available through www.kozmo.com
in San Francisco, L.A. and NYC. Or pick us up at select bookstores and newsstands across the country,
including Barnes & Noble, Borders, Tower Records, Virgin Megastores and Hudson News.

Or, if you purchase the special $49.95 credit package in NerveCenter, you'll get a subscription to the
magazine and 120 credits to use in our personals section. You can use credits to respond to someone's
personal ad or collect call (1 credit) or to initiate a session in the Instant Gratifier (2 credits for a 30 min
session, 3 credits for a 60-min session). Everything else in NerveCenter is FREE, including your Nerve
email account, homepage, e-cards, horoscopes, message boards, advice column and chat. Click here to
check out NerveCenter.

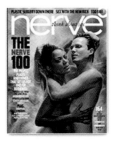

buy the
premiere
issue
click here

preview
Browse the pages of the magazine.

subscribe
Includes single issues and gift subscriptions. The first issue is FREE and you may cancel at any time for a pro-rated refund.
US (US$14.95 / 6 issues)
Canada (US$14.95 / 6 issues)
Int'l surface (US$70 / 6 issues)
Int'l air (US$150 / 6 issues)

edit
Your account
Change address, cancel, look up/change password

above: Nerve is available for users
across media. In addition to the
website, *Nerve* exists as a bimonthly
glossy magazine. The two exist in
complement to one another–each
taking advantages of the best
qualities of their respective media.
"Nerve is not just a magazine, nor is
it just a community site, it is both. It
must be both," says Cavella.

ESQUIRE.COM

A NEW DIMENSION FOR AN ESTABLISHED BRAND

It's one thing to launch a content-oriented site. It's quite another to interpret a popular and established print publication as a new online destination. The key to pulling this feat off is understanding the strengths and weaknesses of each medium and using them as the starting point for the website design. Take, for instance, the online home of *Esquire* magazine. The site isn't designed to be simply a reworking of the print magazine. Instead, it adapts Web-friendly content and uses the interactive medium to create a unique connection with the reader, effectively translating the *Esquire* brand online.

right: The home page of Esquire.com is more evocative of a magazine than of your standard website. Stylized navigation elements alongside the *Esquire* logo guide visitors to the site's main sections. Weekly columns are called out in a left column and feature articles are prominently positioned in the center of the Web page.

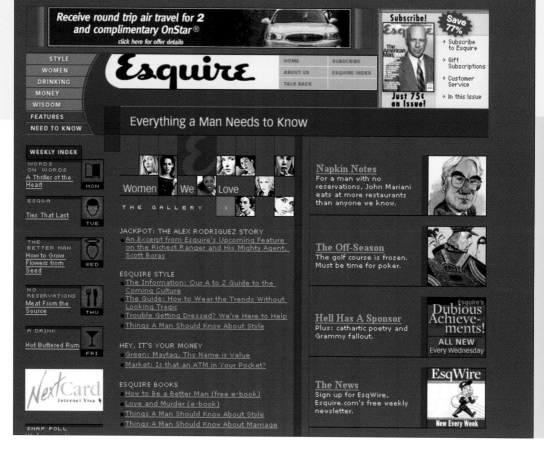

Workshop

Hearst Interactive Studios is the New York–based arm of the Hearst Corporation that is responsible for building and managing Hearst's interests in interactive media.

What Works

Esquire.com is designed to evoke the spirit and character of the print magazine while packaging content in a manageable, timely way. The home page's layout is cohesive and magazine like, with a unifying background color and quick-loading, provocative photography. The site's content is divided into five different categories, so visitors can easily leap from area to area based on their individual interests. But unlike the print magazine, where readers are more likely to remain with long articles, the online articles are much shorter and bite-sized, with images optimized for quick download.

Loyal in its evocation of the print magazine, Esquire.com nevertheless makes the most of the timeliness and interactivity of the Web medium. While the print magazine comes out once a month, Esquire.com is updated each weekday. "We like to make some articles from the print magazine available online, but primarily we like to produce companion and stand-alone content," says Justin Makler, director of production, Hearst Interactive Studios. "Web-only offerings include weekly features such as Dubious Achievements—a satirical look at the week that was—or esQ&A, where users can have questions answered by a style guru. Another example is The Drinks database, which has over 150 drink recipes and stories."

The Drinks database and other archived columns also bring another advantage to Esquire.com—the ability to search through an archive of previously posted information. The site can be used both to supplement the magazine content and to stand alone as a searchable resource. "Areas that provide instruction on clothes, money, drinking, and relationships lend themselves to keeping as reference, copying, and sending to friends," adds Makler.

Work Wisdom

Esquire.com adds another dimension to print articles by offering companion pieces. "Our intention in developing content for Esquire.com is to provide our audience with a variety of experiences," says Abigail Anderson, producer, Hearst Interactive Studios. "In features like the Restless Man travelogue, we have an opportunity to enhance the adventure articles that appear in the magazine with video footage, bringing that natural extended dimension of sound and motion to these subjects. And the print article pushed users to the Website."

The site also includes an extensive audio library. "Literature has always been an important part of *Esquire* magazine, and something that makes it stand out from its competitors," Anderson says. "*Esquire* magazine has relationships with some of the finest living authors, and offering audio on the Website is a way to both capitalize on that and provide users with a richer experience."

above: The online articles are optimized for the medium, with shorter articles portrayed against a white background for easy reading. Links to past features appear at the bottom of each page.

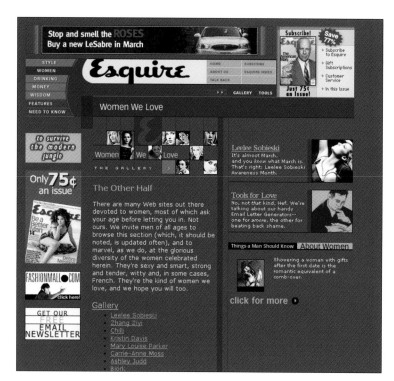

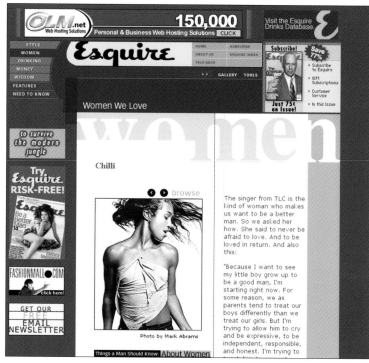

above: It's *Esquire*'s approach to treat all of its subjects with style. Take, for example, the "Women We Love" gallery. As the copy on the site states, "There are many Websites out there devoted to women, most of which ask you for your age before letting you in." Rather, *Esquire*'s gallery includes artful photography and advice from the featured women on how to be a better man.

right and below: Interactive elements such as the Love Letter Generator and e-mailable tips for men from the Things a Man Should Know About Women section add humor and lightheartedness to the site.

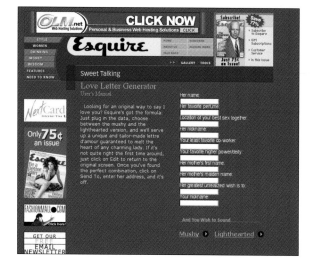

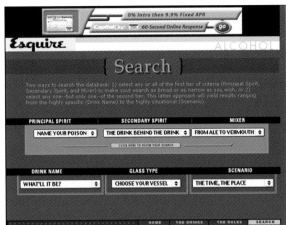

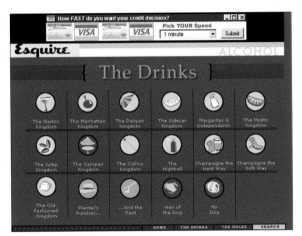

above: The site provides an excellent repository for information such as that found in The Drinks database. Here, you can search through dozens of recipes, each of which includes everything from the desired scenario in which to imbibe the said drink to the recommended glass type. New recipes are added weekly.

right: The website is able to provide content for visitors that the print magazine can't. For example, the audio library includes downloadable and streaming readings from several contemporary writers.

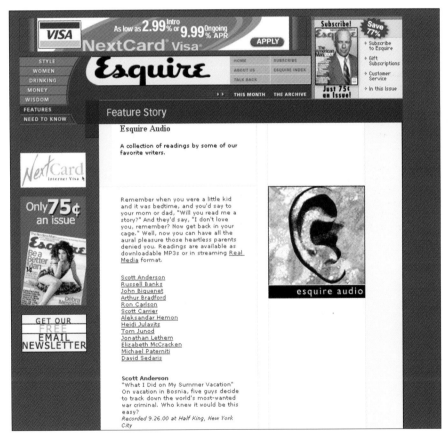

right: As important as it is to have rich content for the user experience, it's equally important for print subscribers to be able to manage their accounts via the site. The Customer Care section allows visitors to see their account status, renew subscriptions, change their mailing addresses, and more.

below: Columns and features from the magazine are reproduced for the site—for example, What I've Learned. Each article links to the contents of the entire issue it came from.

Esquire

Welcome to Customer Care... an on-line link to your personal subscription account.

Use Customer Care to:

- Access your account status
- Make Payment on your subscription
- Find out if your payment has been applied
- Renew your subscription
- Change your mailing address or your email address
- Tell us that you've missed an issue

Enter your email address (i.e., johndoe@provider.com) in the space below:
Note: Even if your email address is not in our file, you can still access your account from this page. Simply enter your email address below and read the instructions that follow.

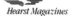 enter | clear

Hearst Magazines

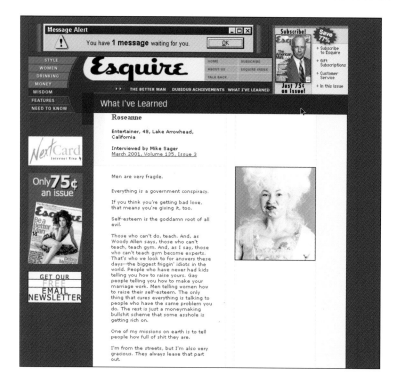

Mongol Machismo
Ulan Bator, Mongolia : Mid July 2001

The Hidden Caribbean

Feeling restless? Herein, howl at monkeys in the (or in any of the other destinations above). Belizean jungle, explore the volcano-savaged island And remember, the here and now can be pretty of Montserrat, and get lost in The Hidden Caribbean good, but elsewhere is always better.

above: The site provides an added dimension to the print features. For example, the Flash Web feature included an interactive world map with links to video clips.

right: Every weekday, a different exclusive Web column is updated on the site, offering a timely content. For example, esQ&A allows user to have questions answered by a style guru.

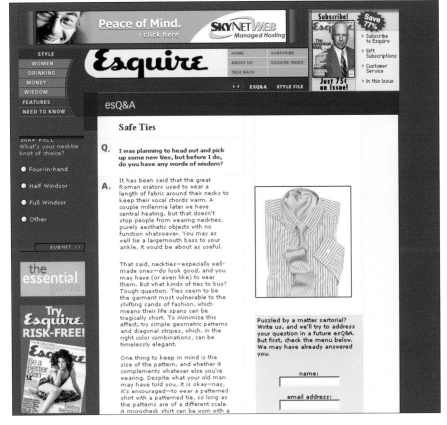

PROMOTIONAL

about manifestival about the films view films: 1 2 3 interactive cinema supporters/

-delic

○ randomizer

an artist?

ogist?

ator?

are

skip int

If there's a site genre that needs panache to succeed, it's the promotional site. These sites must convey the personality of what they're promoting and provide enough content to entice visitors, all while subtly selling something to the customer. Add to the challenge the fact that consumers are inundated with product promotion and that design promotion has to be the most innovative, unique, and creative to get noticed.

The first challenge a promotional site faces is simply enticing the user to type in the URL. Unlike other promotional media like print ads or direct mail, the intended user is an active—not passive—participant. A promotional website needs to make it well worth the user's time to log in. Consider Altoids.com, an entirely compelling, amusing, creative, and clever site whose promotional product is... breath mints. Altoids.com wisely piggybacked on the brand's successful print advertising campaign to create an engaging site wholly worth the visit.

Another example is Splatterpunk.com. When Adobe Systems wanted to attract visitors to a site promoting its Web-design software, the company took an interesting approach, commissioning a site around the persona of a mythical skateboarder named Splatterpunk. A sophisticated paean to design is conveyed through this clever site, which integrates streaming video, vector animations, and sophisticated DHTML programming to create a site that inspires the Web-savvy to deconstruct its design. And that's the hook—these creatives were exactly who Adobe hoped to attract. Learning about the different techniques (all created using Adobe products) takes just a click.

For a creative firm, an evocative Web presence is crucial. In many cases, it serves as a client's first impression of the firm—its face to the world. To be successful, designers need to dig deep and find the soul of the firm, then communicate that through the Web-page design. London's Mediumrare.net is a refreshingly unique—and stunningly simple—site. Rendered against a vibrant blue background is a series of pull-down menus with which the user navigates the site. The result? A brilliantly simple site with a clever approach to navigation that suggests an equally clever approach to project management.

The most important quality of any promotional site is giving center stage to whatever is being promoted. For instance, there's nothing to shroud the work of Booth Hansen at the architectural firm's promotional website. Set against a black background, photography of the firm's work is the site promotion, keeping visitors focused.

A creative firm can also consider its website its foyer, only with a twist. On the Web, you're not bound by the cost of office space per square foot, or by the neighborhood. In a sense, the Internet is the great equalizer of firms, who are now able to be judged solely on their own design ability and firm philosophy. Many of the clients who discovered Lundstrom & Associates Architects online were surprised that the elaborate, sophisticated site was the work of a relatively small office. In essence, the site was the foot in the door to an expanded client base.

And for a promotional site that keeps it simple overall, but uses a compelling home page to entice visitors inside, check out Hillmancurtis.com. Animated intros on the site's home page appear against a minimalist backdrop to tease and promote the different sections of the site. Provocatively simple, the site gives its visitors a great sense for both the firm and the site.

CHEAT SHEET

Navigation: Navigation is important with any site, but it's not the focus here.

Aesthetics: Use the design to create a look or atmosphere for the user—use it to illuminate the content in your site.

Search: Depends—smaller sites can get away with the navigational bar. Make sure the information is easily accessible.

Cutting-Edge Potential: The more narrow and sophisticated the audience, the more adventurous you can be.

Copy Style: Somewhere between the minimalism of e-commerce sites and the verbosity of content sites. Make sure it reflects the tone of the site.

promotional

SPLATTERPUNK.COM

ENGAGING PROMOTION

Promotional sites need a concept—beyond the fact that they are
promoting a product, that is. Product promotion alone doesn't give
visitors any reason to visit the site, unless they're actually looking
for a marketing message. The best form of promotion is coupled
with compelling design and content—something to challenge,
inspire, and entertain visitors. Case in point: Splatterpunk.com.

right: The primary idea
behind Splatterpunk.com
is the creation of a cut-
ting-edge, experimental
Website that just happens
to be created exclusively
using Adobe products.
The approach is invitingly
soft-sell—the content of
the site draws visitors in.
But when visitors want to
explore the "how-did-
they-do-that?" end of
the design, information
about the relevant Adobe
products is no more than
a click away.

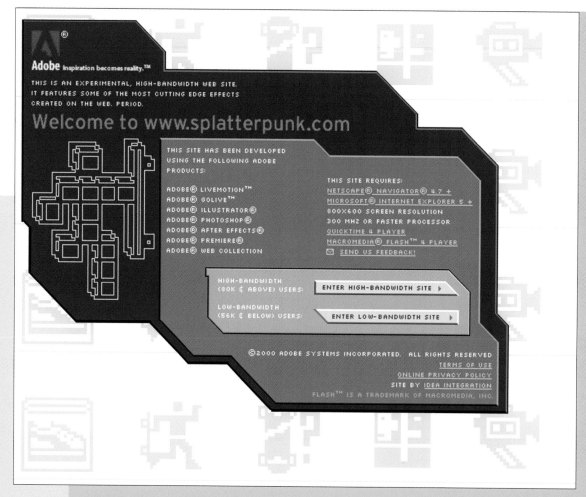

right: The site immediately engages the user asking for an alias to be used as a reference in the site and requesting that the user choose a disguise for the game.

Workshop

Splatterpunk.com is a promotional site created to house Adobe Systems' design and technology experiments by the San Francisco branch office of Idea Integration, a company dedicated to creating Web-based solutions for their clients.

What Works

Commissioned by software developer Adobe Systems, the Urban Legend of Splatterpunk site (www.splatterpunk.com) is addictive and compelling, both in design and content. The site is constructed around the urban legend of an infamous skateboarder named Splatterpunk. Using the video-game inspired interface, visitors navigate through the five different sections of the site using icons—representing sections devoted to evidence, tricks, mystery, rumor, and sightings— to discover information about the notorious Splatterpunk. Images and video are provided as clues to the mystery—and created exclusively using Adobe products.

The design of the site pushes the limits of Web design by incorporating DHTML, vector animations, and streaming video. "The primary objective for this site was to demonstrate the endless possibilities that can be delivered through online media by integrating the various software packages Adobe has to offer," says Todd Keller, project manager for Idea Integration. "It's easy for a site like this to get out of hand by doing too many tricks at the same time with no real purpose behind them. Every trick we used on Splatterpunk.com had a purpose. For instance, the horizontal scrolling creates a feeling that the end user is skating through the city in pursuit of Splatterpunk, and the streaming video give eyewitness accounts of the urban legend."

Work Wisdom

Information about the Adobe software and techniques used in the site design is just a click away. Small icons representing the different kinds of software used on each page are incorporated in the design. Clicking any of the icons summons a features map, which overlays the page with an X-ray effect to provide information about the software and technique.

"To balance the promotional and fictional aspects of the site, we developed two distinct layers of information that would complement each other," says Alex Yra, information designer for the project. "Using the metaphor of an X-ray machine, we developed a flexible navigation system that would allow users to explore the fictional content layer that would advance the Splatterpunk myth, and by activating an infrared 'X-ray,' expose how sections of the fictional layer were designed and created with Adobe products."

The result is a perfectly balanced promotional site: The site design hooks users with an intriguing concept and simultaneously teaches them how to create the same effects on their own. "While the story would encourage movement through one layer to learn more about Splatterpunk, the visuals would encourage movement between layers to learn more about the methods of creation," says Yra. "The number-one priority when it came to designing the site was coming up with enough compelling content that would bring this myth to life and integrate it with the visuals to show off the new features of the software that the client wanted to demonstrate."

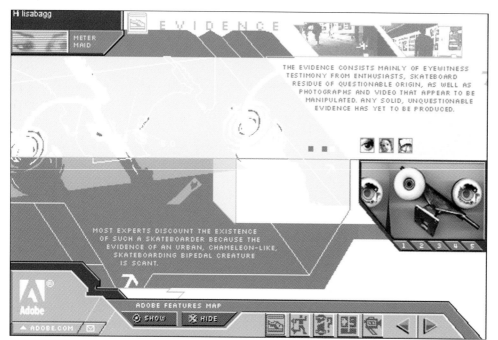

E V I D E N C E

METER
MAID

THE EVIDENCE CONSISTS MAINLY OF EYEWITNESS
TESTIMONY FROM ENTHUSIASTS, SKATEBOARD
RESIDUE OF QUESTIONABLE ORIGIN, AS WELL AS
PHOTOGRAPHS AND VIDEO THAT APPEAR TO BE
MANIPULATED. ANY SOLID, UNQUESTIONABLE
EVIDENCE HAS YET TO BE PRODUCED.

MOST EXPERTS DISCOUNT THE EXISTENCE
OF SUCH A SKATEBOARDER BECAUSE THE
EVIDENCE OF AN URBAN, CHAMELEON-LIKE,
SKATEBOARDING BIPEDAL CREATURE
IS SCANT.

1 2 3 4 5

Adobe

ADOBE FEATURES MAP
SHOW HIDE

ADOBE.COM

left: Once visitors register,
the site introduces them to
the story of Splatterpunk, a
legendary skateboarder.
Using the tools provided
in the video gamelike
interface, users uncover
clues regarding the legend
of Splatterpunk.

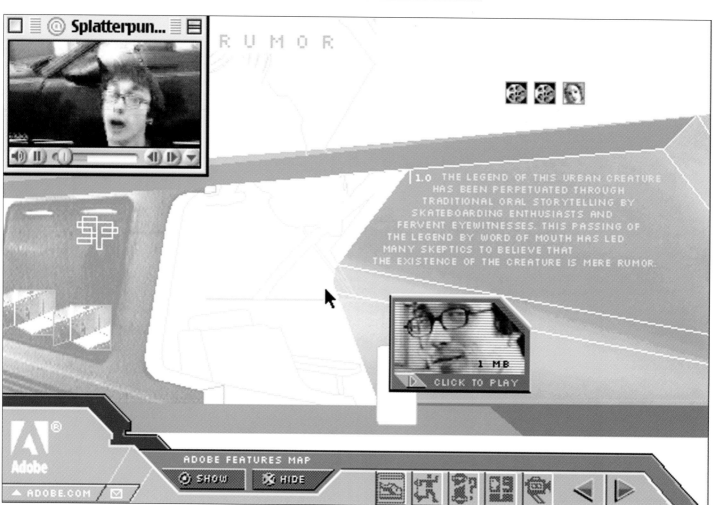

Splatterpun...

R U M O R

1.0 THE LEGEND OF THIS URBAN CREATURE
HAS BEEN PERPETUATED THROUGH
TRADITIONAL ORAL STORYTELLING BY
SKATEBOARDING ENTHUSIASTS AND
FERVENT EYEWITNESSES. THIS PASSING OF
THE LEGEND BY WORD OF MOUTH HAS LED
MANY SKEPTICS TO BELIEVE THAT
THE EXISTENCE OF THE CREATURE IS MERE RUMOR.

1 MB
CLICK TO PLAY

Adobe

ADOBE FEATURES MAP
SHOW HIDE

ADOBE.COM

left: Various media are used to add
context and content to the site. In
the Rumor section, visitors
encounter a eyewitness account of
Splatterpunk in the form of an
embedded movie. Adobe icons in
the upper right-hand corner of the
screen identify the software used to
construct that page.

above and right: Clicking on the different Adobe software icons brings up information about each product and how it was used in the site's development. The information rolls over the screen so the user never loses his or her place on the site.

below: The left corner of the screen contains a menu that takes visitors to more information about all the Adobe products that are used in the development of the site.

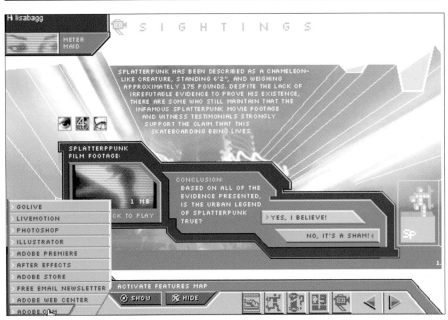

IS SPLATTERPUNK OUT THERE?

above: The way this site is constructed is much more engaging than the typical software promotion site. The use of short, streaming movies is compelling, piquing the visitor's curiosity by tying into the mystery created by the site.

left and below: The site is structured to engage the user whenever possible. After viewing the footage provided to both support and refute the existence of Splatterpunk, visitors are encouraged to take a stand by voting on whether they feel the legend is true. After voting, the "special agents" can see how others voted and view testimonials on the matter.

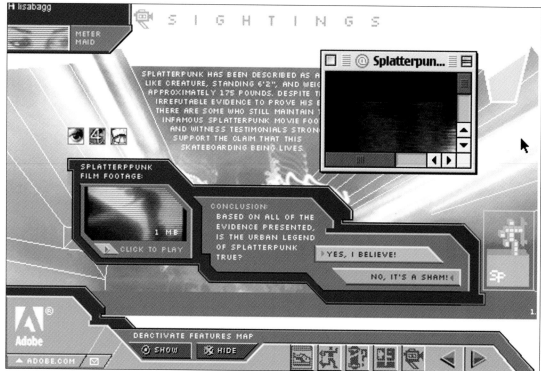

SIGHTINGS

METER MAID

SPLATTERPUNK HAS BEEN DESCRIBED AS A
LIKE CREATURE, STANDING 6'2", AND WEIG
APPROXIMATELY 175 POUNDS. DESPITE TI
IRREFUTABLE EVIDENCE TO PROVE HIS E
THERE ARE SOME WHO STILL MAINTAIN 1
INFAMOUS SPLATTERPUNK MOVIE FOO
AND WITNESS TESTIMONIALS STRON
SUPPORT THE CLAIM THAT THIS
SKATEBOARDING BEING LIVES.

@ Splatterpun...

SPLATTERPPUNK
FILM FOOTAGE:

1 ME

▶ CLICK TO PLAY

CONCLUSION:
BASED ON ALL OF THE
EVIDENCE PRESENTED,
IS THE URBAN LEGEND
OF SPLATTERPUNK
TRUE?

▶ YES, I BELIEVE!

NO, IT'S A SHAM! ◀

SP

®
Adobe

DEACTIVATE FEATURES MAP
◉ SHOW ✖ HIDE

▲ ADOBE.COM ✉

◀ ▶

1.

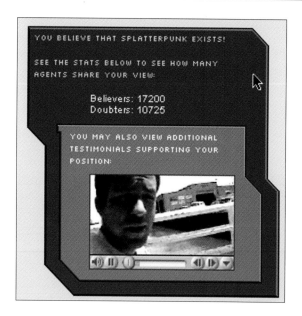

YOU BELIEVE THAT SPLATTERPUNK EXISTS!

SEE THE STATS BELOW TO SEE HOW MANY
AGENTS SHARE YOUR VIEW:

Believers: 17200
Doubters: 10725

YOU MAY ALSO VIEW ADDITIONAL
TESTIMONIALS SUPPORTING YOUR
POSITION:

above: In addition to information about the different Adobe software products used to create this site, information about special new features in different Adobe products is provided as well. This inspires people who already own the software to upgrade and adds to the site's credibility as an online destination that pushes the limits of design.

targeting and focus

It is nearly impossible for a website to be all things to all people. The broader the approach, the more likely you are to miss the target.

When creating a car, refrigerator, magazine, or website, designers must define their target market clearly. But

even having a distinct picture of this audience may not be enough to create a truly useful product.

Nike makes a wide range of shoes, suitable for all type of athletes. They do not make one shoe style for everyone. That would be impossible. Each shoe is designed with a unique group of athletes in mind. This group of athletes can be represented by a few individuals, each personifying the needs of their class or type. This is called creating user profiles. Profiles represent archetypal users who must, by any means necessary, be satisfied on every visit to your site. These profiles are defined by their goals. Ask yourself, what do users seek to communicate, learn, transact, or create on your website?

By having a definition of your profiles and their goals, you can more easily answer questions about your users' information, functionality, and interface needs. Profiles help answer these questions correctly, preventing costly mistakes derived from making incorrect assumptions about your audience. This becomes particularly telling when addressing a global audience, where the profiles' needs might change slightly based on cultural differences.

Note that Chapter 9 of Alan Cooper's *The Inmates Are Running the Asylum* (Sams, 1999) has an excellent explanation of the profile concept.

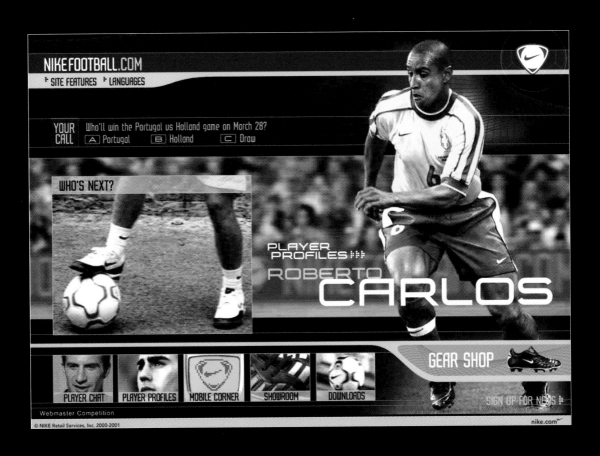

BOOTHHANSEN.COM

www.boothhansen.com

A MINIMALIST SITE WITH CONTEXT

Many companies spend so much time cultivating the physical style and identity of their Websites that the site's focus becomes diluted. When visitors have to wade through too many levels to find what they want, it's hard for them to tell what's important or to locate specific information when they're looking for it. And few sites bother building on the actual character of the individuals and community behind them. Doing this is particularly important when it comes to promotional websites—it's an opportunity to provide some context for the company's personality.

right: Booth Hansen's site is comfortably uncomplicated, with simple type reversed out of a black background and basic navigation labeled "what we do," "who we are" and "contact us." Photographs of the firm's work stand out prominently against the black background.

BOOTH HANSEN what we do who we are contact us

BusinessWeek
architectural record awards

Site design by Dotology. © 2000 Booth Hansen Associates.

Workshop

The site was designed by Chicago's renowned Web-design firm Dotology.

What Works

Booth Hansen is a Chicago-based architecture firm that has taken on projects for clients ranging from homeowners to the Catholic Church. The Booth Hansen site is much more than an online portfolio of past jobs or a laundry list of client names. Rather, the site not only describes the evolution and method behind different architecture jobs, but also includes photographs and bios for many of the staff members. "I felt very strongly that the visitor should have a sense of who we are, not just what we do," says Sandy Stevenson, principal of Booth Hansen. "Many firms include nice pictures of their project work, but you don't get a sense for who they are, let alone whether you would want to work with them or not. We felt the only way to do that was to focus on our people, in an attempt to convey our culture and values."

Work Wisdom

The site design is simple but effective, reversing the copy out of a black background and running a series of thumbnails in the bottom frame that, with a click, enlarge into full-size photographs of the work in question. The thumbnails sit in a horizontally scrolling frame in the bottom of the screen, allowing visitors to browse through a variety of work at once, arranged by project category. "We developed this approach to both convey the breadth of our work as well as serve as a simple navigation tool," says Stevenson. "We assumed that some visitors to the site were only interested in a specific building type, so we didn't want them to have to wade through a layered site to get what they wanted to see." While allowing visitors to jump right to what they're interested in, this structure is also a quick and easy way for visitors to browse through the firm's portfolio of past work.

right: Thumbnails, identified by category, are featured in the bottom frame of the screen. This serves as an excellent introduction to the breadth of Booth Hansen's work, while maintaining the site's minimalist presentation.

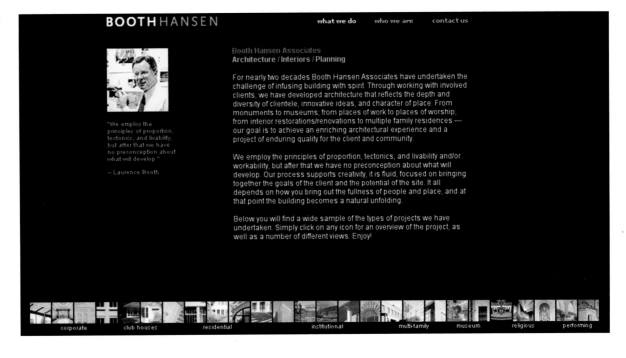

above and left: Detailed accounts of how different projects came together are an essential element of this site's success. Each story is accompanied by a series of photographs showing details of the project, along with some insight into the architectural philosophy that guided that particular job.

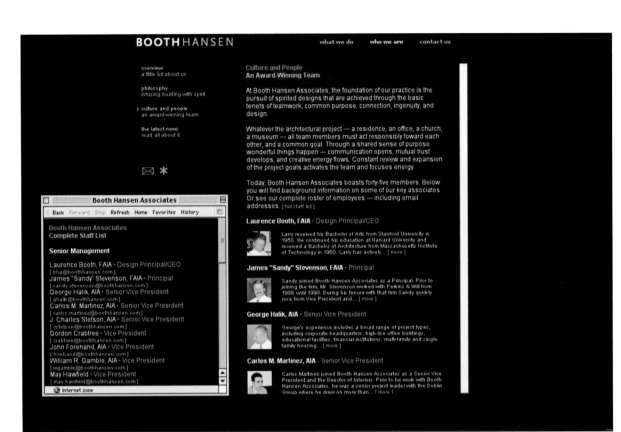

above: To give visitors an accurate feeling for the personality of Booth Hansen as an office, it was important to put the staff members' names with their faces. Portraits and bios of all the key management staffers are included here, along with a complete roster of employees accompanied by e-mail addresses.

right: Part of evoking the personality of Booth Hansen was including insight into the firm's philosophy, information included in the who we are section.

LUNDSTROMARCH.COM

SETTING ITS SITE HIGH

On the Web, no one knows how big you are. A company's website is its face to
the world and, in many cases, prospective clients' first encounter with it. In
that respect, it's the quality—not the quantity—of the presentation that's most
telling. Lundstrom and Associates Architects has found its well-designed,
artfully executed site to be a major competitive advantage—it helps level the
playing field when competing with more established firms twice their size.

right: LundstromARCH.com
provides its visitors with two
choices right off the bat—to
opt for the more elaborate
Flash "deconstructivist"
version of the site, or to choose
the faster-loading HTML
"constructivist" version, which
allows all visitors access to the
site, no matter what the speed
of their connection or which
platform they're using.

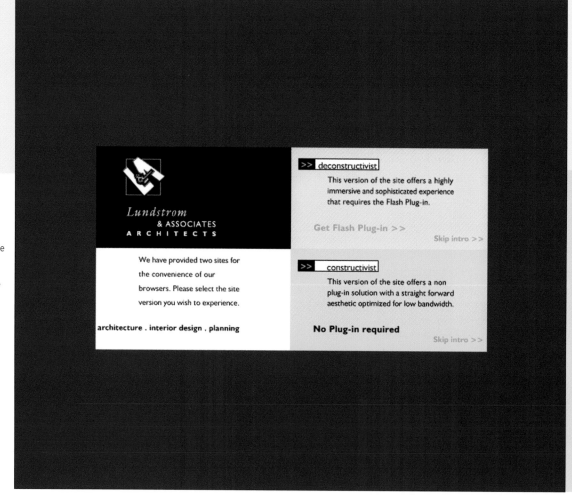

right: The splash screen in the Flash version of the site offers an animation that asks, "What is an architect?" This is the firm's opportunity to convey a bit of its company philosophy along with offering an enticing welcome to the site.

Workshop

Lundstrom Architecture is a Newport Beach, California–based architecture firm with twelve full-time employees. The site was designed by the Newport Beach, California–based interactive firm Juxt Interactive.

What Works

The site design is sophisticated and sleek, thoughtfully adapting itself to the needs of various users with two different versions. The "deconstructivist" version offers the all the bells and whistles expected from Flash, including an elaborate splash screen, engaging animation, and fluid transitions between each section. The "constructivist" version offers users with slower connections, or without the Flash plug-in, the opportunity to experience a basic version of the site with the same information, but a more bandwidth-friendly structure. It was important to the firm to create a dramatic visual statement with the design. "We thought that doing something really creative and not static would capture the imagination of the people we were trying to reach," says Jon Lundstrom, principal of Lundstrom and Associates Architects. "By creating a site like this, we were instantly able to compete with firms larger and more sophisticated, since this was many people's first impression of us."

Work Wisdom

The site is designed to speak the language, both visually and contextually, of its visitors. The design is appropriately modular, evoking the spirit of architectural elements through the layout. Greatly detailed information about the firm itself and past projects belies the firm's modest size. "The site is organized much like an architect prepares for a client presentation, in terms of navigation, flow, presentation, order," says Lundstrom.

The portfolio pieces are presented as case studies with each job explained by first identifying the problem at hand, then detailing the solution found by the firm. From there, the visitor can see close-up images of the work and a variety of other ancillary information about how the job came together. By avoiding a formulaic approach, the site immediately connects with the user.

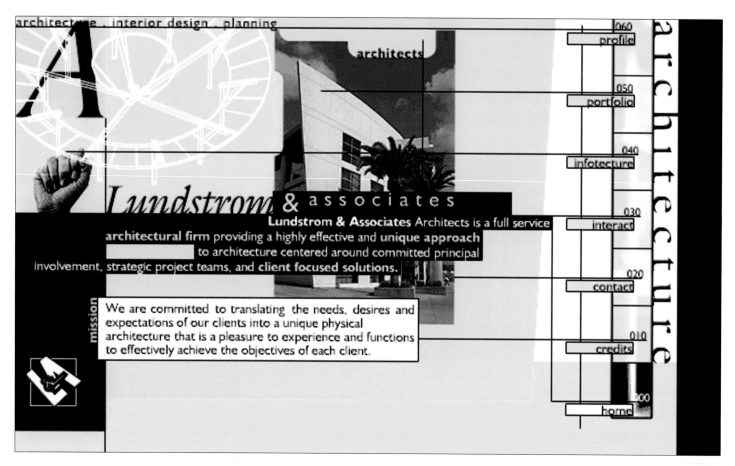

above: LundstromARCH.com is designed with a modular flair, evocative of the very nature of architecture. The six main areas are included down the right side of the screen, allowing people to browse the site's portfolio, get a profile of the firm, and easily reach a list of contacts.

right: The site makes its staff accessible through a detailed contact page, which includes the staff's names, titles, and e-mail addresses so it's easier to connect with the right person.

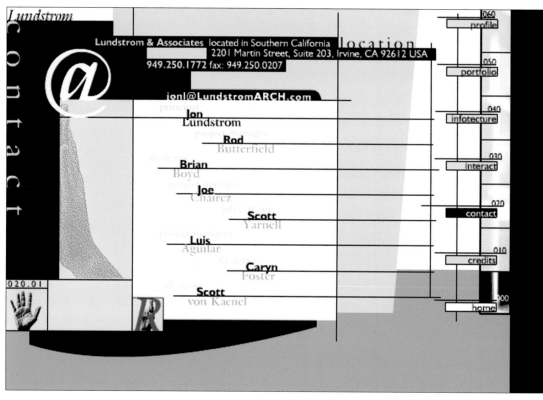

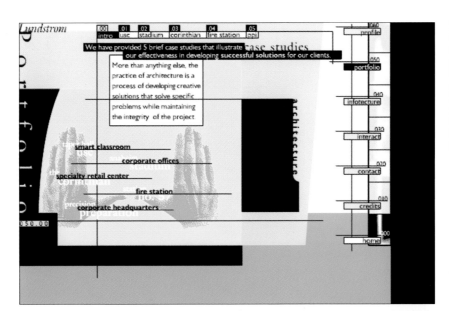

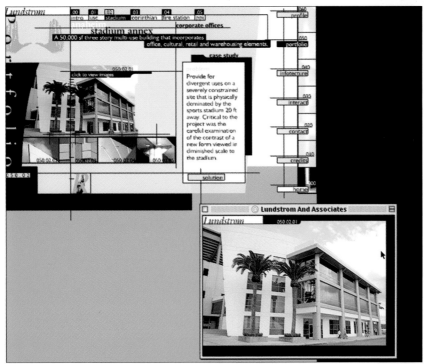

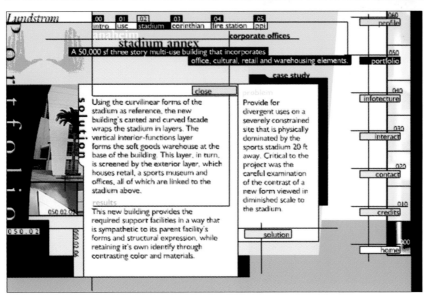

left: Each of the projects included in the firm's portfolio has a case study that demonstrates the problem/solution approach that Lundstrom and Associates Architects, Inc. brings to the table. The site's design and presentation suggest a sophistication and expertise far beyond what's expected from firms its size.

www.mediumrare.net

MEDIUMRARE.NET

INTERFACE INNOVATION

Pretty self-promotional sites aren't without merit—attractive design demonstrates a strong aesthetic and establishes a firm's style. But when a firm takes the extra step to show that it can innovate as well as create a good-looking site, it clearly sets itself apart. Against the backdrop of a simple but eye-catching design, the online home of mediumrare distills its interface to its purest form. By experimenting with the navigation, visitors can chart their own experience and learn more about who mediumrare is.

right: mediumrare's site design is kept intentionally simple to draw the visitor's eye straight to the site navigation. The visitor uses two simple drop-down menus to begin learning what mediumrare is, does, likes, or understands— the site unfolds from here.

Workshop

mediumrare is a London-based multimedia design and communication firm. Past projects have included work in brand identity, digital media, and TV/broadband. Clients include the BBC and Levi's.

What Works

The site's design is unquestionably minimalist, with a strong positive impact. Upon arrival, visitors encounter a vibrant blue screen with the firm's logo prominently rendered in black, accompanied by simple drop-down menus that urge visitors to choose to discover what mediumrare is, does, likes, or understands. Depending on the selection, visitors are presented with more menus containing options that reveal more and more about the firm. "You have to play and explore on the site to move forward," says Toby Stokes, a designer for mediumrare. "You build your own site on the way in and understand how you got there on the way out."

The site's design is intentionally kept spare to keep the visitor's focus on the navigation and interface. It's the logo and menu that get the attention—as the visitor makes choices, images appear in a frame in the top third of the screen, while the bulk of the screen remains mediumrare's signature blue. "If you're asking visitors to understand fairly tricky ideas for an interface, it's best not to obfuscate everything with shiny graphics," says Stokes.

Work Wisdom

By immediately presenting the user with provocative navigation against a simple layout, the design immediately entices the user. And by creating a clever—but simple—approach to the site navigation, mediumrare proves that it can bring that same imaginative approach to new design jobs and clients. But most importantly, the site shows a reverence for the essence of Web design. "The interface exposes the basic tree structure of a site, which underlies most sites, no matter how you dress them up," says Stokes.

right: Although most of the screen is kept spare, as the visitor makes selections from the drop-down menus, corresponding illustrative elements appear in the upper third of the screen.

left: With each menu choice, more menus emerge, offering more choices. The visitor is allowed to drill deeper and deeper to discover more about the firm, like the client list shown here.

below: Exploring the mediumrare site is all about discovery—along the way, you find the necessary facts about the firm itself, but you also learn a little more about what makes it tick. For instance, here the firm offers up some of its favorite fonts.

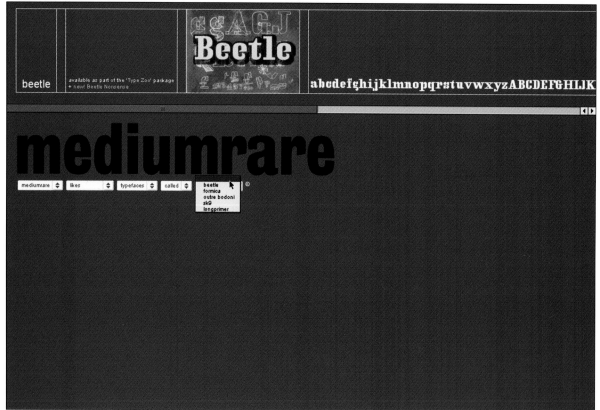

right and below: In an effort to be different, the site doesn't abandon crucial information like client lists or portfolio work—it just showcases it in a creative way. Once you navigate to the variety of things mediumrare "does," you discover the different clients the firm has worked with and the work that was done for them.

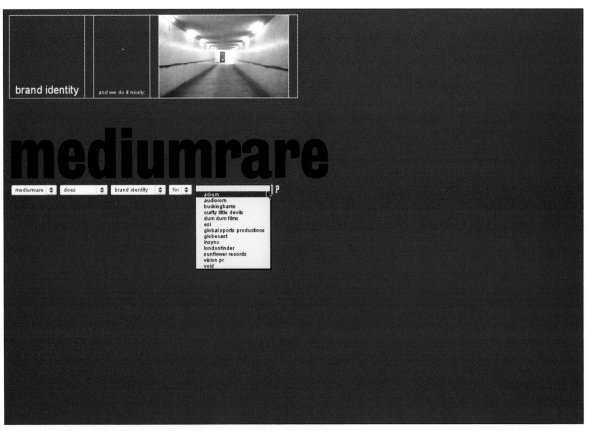

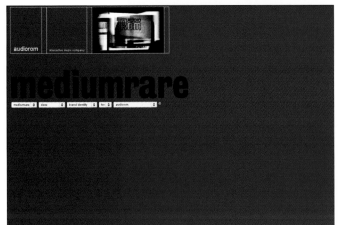

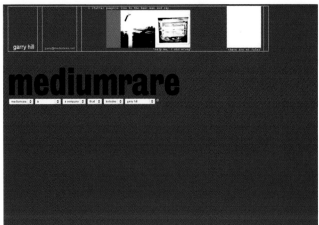

above: The unique site design also allows the quirky personalities of the mediumrare staff to shine through. When browsing through the staff list, you'll find original designs created by each person, along with e-mail contact information.

HILLMANCURTIS.COM

PROMOTION AND INSPIRATION

A danger when creating a promotional Website is laying the promotion part on too thick. Repeated breathless claims about "award-winning" work written as traditional marketing copy can create a message so predictable that it automatically gets tuned out by the user. For a site to stand out from the rest and connect with the visitor, it has to capitalize on its individuality—and show some personality. Hillmancurtis.com is a site that isn't afraid to let the merit of its work carry the design and give deference to the visions of predecessors who helped inspire it.

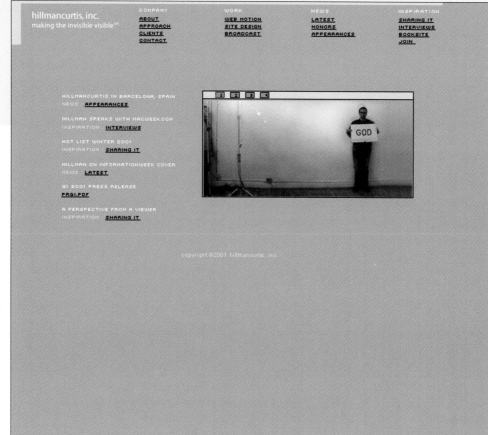

right and opposite: Short Flash movies featured on the home page creatively introduce visitors to the different areas of the site. An animated movie showing Hillman Curtis holding a series of cards reveals the phrase "God is in the details" to introduce visitors to the Inspiration: Sharing It section of the site. A stylized animation of an airplane flying introduces visitors to the section on motion graphics.

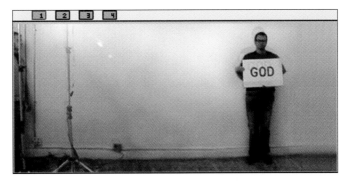

Workshop

Hillmancurtis, Inc. is a New York City–based design company specializing in motion, Web, and broadcast design.

What Works

The site is an elegant introduction to the firm, conjoined with some of the character of the company. Modest type is set against a simple gray background, immediately drawing the eye to a series of short animated teasers created in Flash. A short movie of an airplane flying promotes the Web Motion section of the site, and a man flipping through a series of different magazine promotes the site's News section. Best of all, these enticing movies don't bog down the download time. "I really love the idea of having a defined area where we can post motion," says Hillman Curtis, chief creative officer of Hillmancurtis, Inc. "The parameters I set are strict—no movie can be longer than ten seconds or weigh more than 50 K."

The site design is Curtis' physical representation of the firm itself. "The site is the simplest and most consistent design I could come up with," says Curtis. "It's thoughtful—everything is in the same place. It's super-fast on the download, and the information is clear, tight, and easy to get to. Its design is based on respect. Hillmancurtis, Inc. has always worked to design for the message, for emotional resonance, theme, and functionality."

Work Wisdom

Beyond the portfolio pieces, you get to know a little bit more about what makes Hillmancurtis.com tick in the Inspiration section of the site. Here, you'll find links to other exceptional sites, innovators, and writings on design. "If there's one single important thing that I have learned as a designer, it's to honor the work of others," says Curtis. "To avoid competition, to keep your eyes and ears open because there's usually inspiration in front of you, to the side of you, behind you, and it will help you with ideas. It will power you forward. We had no choice, we had to put the Inspiration section up there. It's too much a part of our company to ignore."

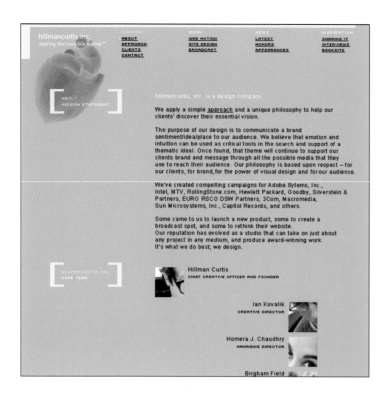

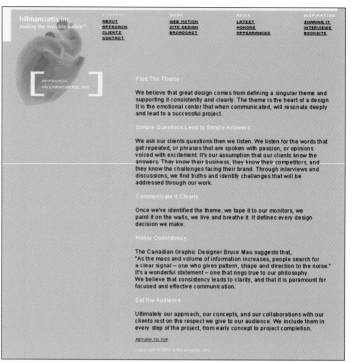

above: The site explicitly spells out the approach that Hillmancurtis, Inc. brings to its projects. The bells and whistles found on other sites are abandoned for a straightforward, fast-loading introduction to the philosophy of the firm. "The idea is to present the clearest, most consistent, and intuitive environment in which to showcase our studio, work, and philosophy," says Curtis.

right and below: Simple thumbnails representing past projects link to more detailed descriptions of each job. The pages load extremely quickly and provide the information in a tight, easily accessible format. Links bring up the projects themselves, like this job for 3Com.

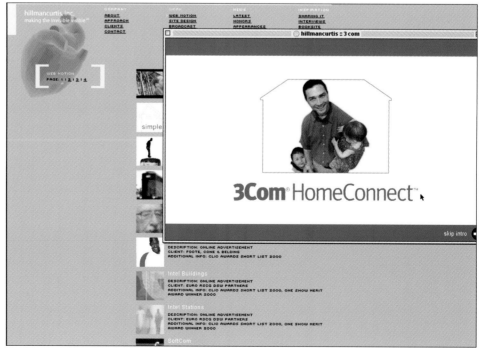

above left: The site provides the latest about the company, along with links to articles that mention Hillmancurtis, Inc. and a list of awards the firm has won.

above right: Curtis humbly credits his firm's success to the inspiration of other innovators—the site's Inspiration: Sharing It section is devoted to them. "The literal translation of the word inspiration is 'the act of drawing in'; specifically: the drawing of air into our lungs," says Curtis. "As designers, inspiration is our air. It powers you forward."

right and below: Thumbnails link to work the firm has done, launching windows like this one, showing the site Hillmancurtis, Inc. created for the Manifestival.

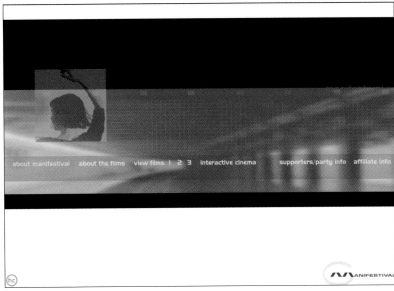

ALTOIDS.COM

CONVEYING PERSONALITY ONLINE

Consumers are predisposed to tuning out marketing messages—
televisions are muted as soon as shows break for commercials and junk
mail is tossed out before it's even opened. Plus, TV and direct mail are
marketing media that allow the user to remain completely passive.
Conversely, a promotional website has to inspire users to take the
initiative to visit the site on their own. The first key to creating an
effective promotional website is to can the marketing-ese—your site
will gather dust if it's constructed solely of customer testimonials and
copy written by the marketing department. Instead, the site should be
interesting and fun—and contain something that evokes the brand. In
other words, take a page from Altoids.com.

Workshop

Altoids.com was designed by the New York City office of Red Sky Interactive.

What Works

You have to be doing something right if you design a site that gets visitors excited about breath mints. Wisely picking up where the successful Altoids advertising campaign leaves off, Altoids.com incorporates humor, provocative design, and personality to bring the Altoids brand to life. Each page is designed as a billboard made up of a rotating selection of different modules promoting the different areas of the site, all rendered in the trademark shape of the Altoids tin.

"To make the site successful, we knew we had to grab people's attention quickly and offer enticing reasons to return," says Louise Zonis, project director for Red Sky Interactive. "Humor was integral to the design, the content, and the overall brand strategy. Altoids.com set out to be an entertainment site, where teens and adults would most likely engage for, ideally, up to five minutes in the diversity of sights, sounds, stories, and factoids."

Work Wisdom

The site features a variety of fun, interactive elements, like games, promotions, and interactive message boards, but perhaps the most unique and unexpected parts of the site are the sections where emerging artists and experimental Web design are showcased. If you think that has little to do with mints, guess again. It's all about branding and positioning the site for the intended user.

"The Altoids brand sought to identify with an irreverent, urban, offbeat subculture," says Zonis. "Consequently, one of our primary objectives was to engage emerging artists to help shape the sensibility of Altoids on the Web. We designed the site to showcase the illustrations, sound mixes, creative writing, and interactive components of a host of artists with whom we collaborated."

All of this helps to elevate the Altoids brand beyond a simple product, into a sort of culture. "We designed the site to draw people into an environment of humorous, dynamic content that embodied the 'curiously strong' spirit of the brand," says Zonis. "On the surface, you eat mints, but you're actually ingesting a culture."

above and right: Visitors have more incentive to stop by Altoids.com than just to pay homage to their favorite breath mints. The interactive Web exhibit, for example, provides examples of innovative website designs by emerging artists. This section is all about connecting with the intended Web audience and attracting a hip, creative subculture of visitors and, ultimately, customers.

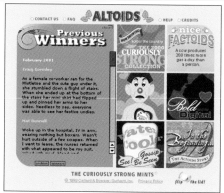

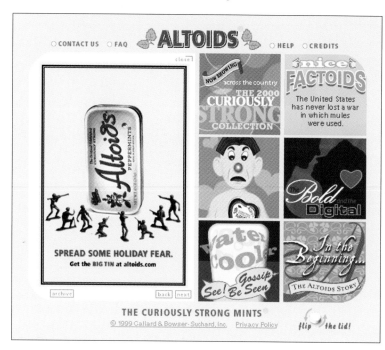

above: The site's design and content convey a playful, mischievous persona, a quality also found in Altoids' advertising campaign. For instance, the Holiday Bonus Winners sections invites site visitors to rat out coworkers by spilling embarrassing stories of company holiday parties—winners get a cool $50.

left: Altoids.com wisely picks up where the popular Altoids advertising campaign left off. Elements from the Altoids print advertising are integrated into the site in the Outside the Box section, uniting the marketing message of both media.

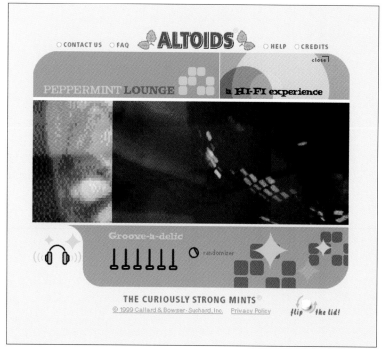

left: The site pushes technology to create a unique experience for site visitors. For instance, the Peppermint Lounge features original, interactive music created using Shockwave.

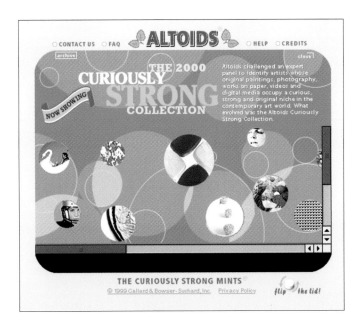

above and right: Altoids' tagline is "the curiously strong mints," a distinction that is repeated throughout the site. The Curiously Strong Collection includes original paintings, photography, works on paper, videos, and digital media that are deemed to occupy a "strong and original niche" in the contemporary art world, integrating the Altoids brand message with original content.

below: The playful (literally) and interactive Hi Jinx section includes Flash games and free downloadable items such as Altoids icons.

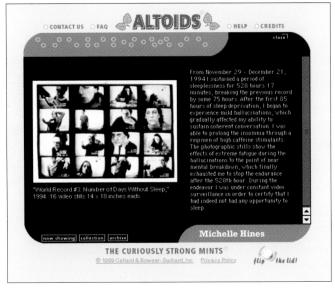

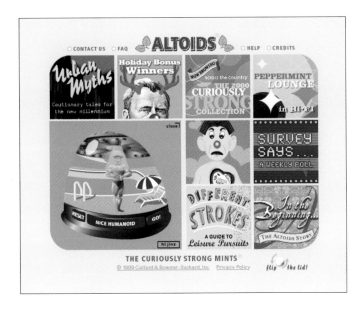

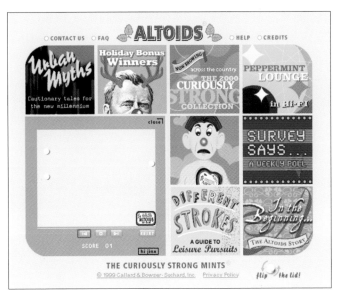

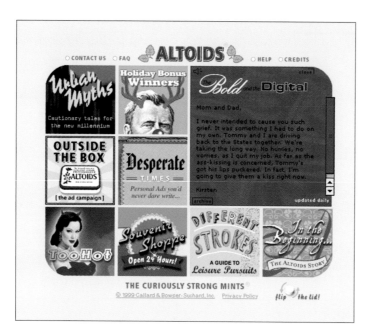

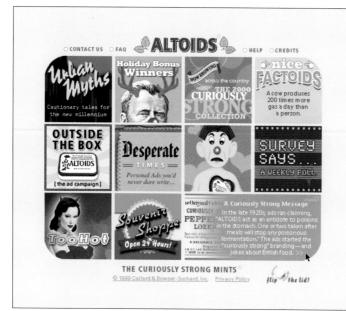

above left: A clever, humorous, and relatively effortless way the site stays fresh and keeps people coming back is through the daily travails of The Bold and the Digital, whose soap-opera-inspired exploits are updated on a daily basis.

left and below: Amid all the frivolity on the site, it was important to give Altoids a little context by telling the mints' history and how the company came to be. The copy is written in a subtly cheeky way in keeping with the tone of the site, but it gives customers a feel for the company itself.

above: The focus of the site is to promote the Altoids brand and, ultimately, sell more mints. The Souvenir Shoppe, with its retro flavor, sells Altoids products straight from the site.

Courtesy of Altoids®

PORTALS

		SYMBOL	PRICE	CHANGE
R		DJIA	10,472.90	-450.60
BARNEY		Nasdaq	3,424.61	-252.17
[Quote]		S&P 500	1,380.42	-60.09
Name				

Updated 04.18.00 @ 3:30pm
Quotes delayed at least 20 mins.
Disclaimer

Reuters : Stocks Gored; Dow Off More Than 400 Points
CBS Marketwatch : Stocks Tank; investors panic.
CNET News : High-tech CEOs chalk up large paper losses.

CAREER CENTER
Put Your Job Opening Online
Broadcast your job opening to million of candidates in minutes.

finance

he Street:
Treasuries
rketwatch:
t filings and
each week

Stock of the Week:
Learn about the stocks picked by Standard and Poor's equity analysts

PORTFOLIO FORECASTER
Get your your portfolio analyzed to get a clearer picture of your financial future.

MY PORTFOLIO

Login	Sign-Up

"It's addictive

type in a question and click Ask!

Portals are the conundrum of the Web-design world. Designer William Drenttel put it best when he said: "Portals are a great design challenge. There's not an analogy to a portal in the world of print. Hundreds of links to every type of information in the world, including advertising and content, is a complicated thing to sort your way through."

Amen. Designing a portal means considering thousands of links to widely varying information, the broadest range of possible users, and the unknown potential for future expansion. But portals are the backbone of the Internet, the essential places that connect users with their intended sites.

One of the paradoxes of designing a portal is that, for the most part, the intent is to send visitors to other sites. It's the portal's job to usher visitors there as quickly as possible—not to be the end destination. This is a noteworthy shift in philosophy from pretty much every other site you're likely to find. In this chapter, you'll discover some portal sites that serve this mission well by offering great resources and compelling visitors to return again and again—the true key to a portal's success.

Google is a perfect example of an effective portal, with absolutely nothing superfluous about its design. The home page features a prominent keyword-search field and some understated links to help visitors drill deeper if they're interested. Both the site's technology and its simple design help visitors immediately find the sites they're looking for.

It's important for portal design to accommodate the wide variety of different users who are likely to visit a site—this includes niche portals, too. Spinner.com is a music site that caters to a wide variety of musical tastes with simple designs that are carried by the features for each subject area.

The very nature of portals suggests future expansion, as the amount of information the portal references grows with the Web. A portal's framework must be designed to support this growth—it doesn't make sense to have to redesign the portal with every information explosion, and simply tacking on new sites will clutter and confuse the interface. Netscape.com's structure is designed to organize a great deal of information comfortably in one place and facilitate future expansion.

At times, the efficiency of portal design borders on impersonality. While delivering a swift collection of returns, a portal may in its haste return some far-out responses that aren't germane to the subject. About.com has taken a much more personal approach to site recommendations by assigning human "guides" to be the custodians of different subject areas. These expert guides hand-pick links and interact with the site's visitors.

Another obstacle in many portal designs is the clunky language visitors must use in their queries. Vague keyword searches produce vague answers and often prevent visitors from finding the information they seek. Ask Jeeves accepts user queries in natural language. Rather than guessing which keywords to use to target a search, visitors type their queries as complete questions, making it much easier for visitors to find what they're looking for.

CHEAT SHEET

Navigation: Absolutely vital to a successful portal.

Aesthetics: Even less important than with e-commerce sites. This doesn't mean that the design has to be ugly, just focused on smart navigation.

Search: As essential as navigation.

Cutting-Edge Potential: If used to expedite searches, go for it, but otherwise, forget it. This is not the place for design experimentation; the structure should be accessible to everyone.

Copy Style: Keep it to an absolute minimum unless your site is providing information under one of its established links.

portals

GOOGLE.COM

SIMPLICITY AND SPEED

Search engines pose a curious challenge—after all, their goal is to
quickly usher their visitors to *other sites*. But search engines are
the backbone of the Internet—the link that connects sites to their
intended users. A well-designed search engine should create as
direct a connection as possible to targeted information. Both in
structure and aesthetically, Google is about as streamlined and
focused as possible—with little to stand between users and their
search results.

Search 1,346,966,000 web pages

rockport books

Advanced Search
Preferences

Google Search I'm Feeling Lucky

Google Web Directory
the web organized by topic

Do-it-yourself keyword advertising. Google AdWords works.

Cool Jobs - Add Google to Your Site - Advertise with Us - Google in your Language - **All About Google**

@2001 Google

Workshop

Google is an Internet search engine based in Mountain View, California.

What Works

There is absolutely nothing superfluous about the design of Google—the guiding philosophy of the site is to keep everything as straightforward as possible. The home page features little more than the Google logo, a keyword-search field, and a few links. There are two buttons under the keyword field: Google Search (which delivers all the results Google can dig up for the specified keywords) and I'm Feeling Lucky (which automatically takes visitors directly to the first page Google returns for a query).

"We felt that many of the other search engine sites were overdesigned," Marissa Mayer, software engineer for Google. "We wanted to reduce the clutter so the focus is very clear and people will be able to quickly find what they're looking for. We want to help people find information as quickly as possible and move off our site into the results they seek. The design was kept minimalistic so the pages would load extremely quickly."

Work Wisdom

The burgeoning number of sites populating the Web means that search engines need to find an effective way to deliver the most relevant results to their visitors. Without effective back-end technology to help deliver search results, a search-engine site would fail in its mission. The technology that Google developed is named PageRank—a system of ranking website results for a particular query based on how many other sites link to them.

"PageRank assesses the popularity of sites online," says Mayer. "The link structure says something about the Web. You don't link to someone's site if you don't respect it. This incorporates a type of word-of-mouth recommendation into the Web."

opposite: The design of the Google home page couldn't be simpler: a logo, a keyword-search field, and a few targeted links. The approach is quite different from other search engines, with home pages that pack every pixel with hotlinks. The philosophy is to keep the design simple and the focus clear.

right: A link on the Google home page takes users to a Web directory, which includes a variety of categories and subcategories that users can browse for information rather than using a keyword search.

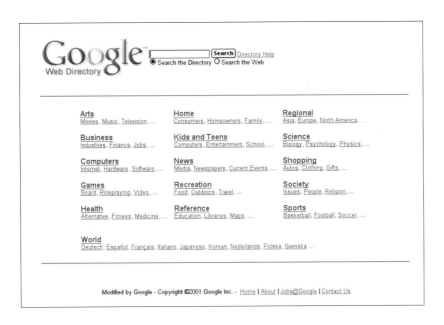

Advanced Search Preferences Search Tips

rockport books [Google Search] [I'm Feeling Lucky]

Searched the web for **rockport books**. Results **1 - 10** of about **18,600**. Search took **0.63** seconds.

RockPort and more available in our Fashion Accessories department Sponsored Link
www.QVC.com **Ready to shop? Visit iQVC for everything on your shopping list.**

Category: Business > Industries > Publishing > Publishers > Nonfiction

Rockport Publishers, Inc.
Category: Business > Industries > Publishing > Publishers > Nonfiction
www.rockpub.com/ - 2k - Cached - Similar pages

rockport publishers **books** -- 6
books company community news rotovision. architecture, crafts, fineart, graphic
design, interior design, lifestyles. Lifestyles. ...
www.rockpub.com/books_top.asp?book=6 - 9k - Cached - Similar pages
[More results from www.rockpub.com]

Rockport, Texas maps&travel **books**
Rockport, Texas maps&travel **books**. This report has
been optimized for printing of maps with ...
books-maps.com/US_TX/RKP.html - 53k - Cached - Similar pages

Rockport Publishing Pastel **Books**
ROCKPORT PUBLISHING **BOOKS**. THE BEST OF PASTEL. The
Best of Pastel was published in 1996 with 200 ...
www.dakotapastels.com/rockportbook.htm - 5k - Cached - Similar pages

Camden-**Rockport** Historical Society **Books**
Camden-**Rockport** Historical Society's **Books** Reprints of **books** done by the Camden-**Rockport**

above: A simple keyword search
for Rockport Books almost
instantaneously produces this list of
results. The more web pages that
link to a site, the higher up it will
show in the queue of results.
A blue bar at the top of the page
identifies the number of results
found for that subject and clocks
the amount of time the search took.

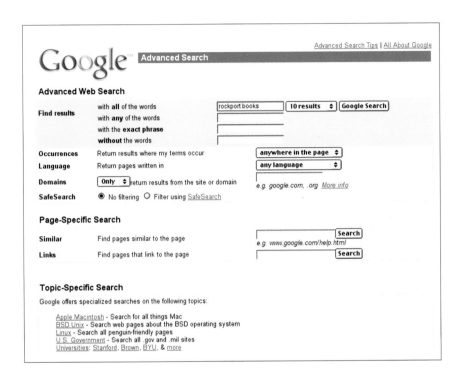

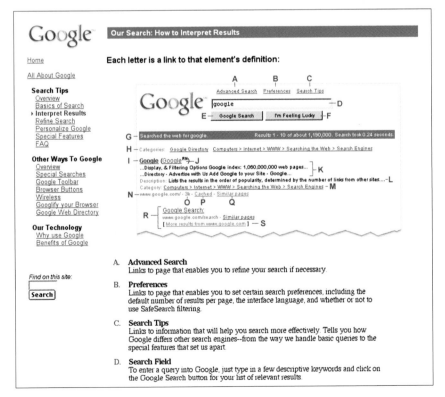

left: Google's interface philosophy is to make initial pages as uncomplicated as possible, then offer visitors the opportunity to create more complex searches if they wish to. The advanced search allows users to set a variety of parameters to target their searches, and information on how to use the site is readily available.

A. **Advanced Search**
Links to page that enables you to refine your search if necessary.

B. **Preferences**
Links to page that enables you to set certain search preferences, including the default number of results per page, the interface language, and whether or not to use SafeSearch filtering.

C. **Search Tips**
Links to information that will help you search more effectively. Tells you how Google differs other search engines--from the way we handle basic queries to the special features that set us apart.

D. **Search Field**
To enter a query into Google, just type in a few descriptive keywords and click on the Google Search button for your list of relevant results.

Google™ Preferences

Save your preferences when finished and **return to search**. [**Save Preferences**]

Interface Language Display Google tips and messages in: [English ⬍]

Search Language ○ Search web pages written in any language (Recommended).

Search only these selected language(s):

☐ Chinese (Simplified)	☐ Finnish	☐ Italian	☐ Portuguese
☐ Chinese (Traditional)	☐ French	☐ Japanese	☐ Romanian
☐ Czech	☐ German	☐ Korean	☐ Russian
☐ Danish	☐ Greek	☐ Latvian	☐ Spanish
☐ Dutch	☐ Hebrew	☐ Lithuanian	☐ Swedish
☑ English	☐ Hungarian	☐ Norwegian	
☐ Estonian	☐ Icelandic	☐ Polish	

Number of Results Google's default (10 results) provides the fastest results.

Display [10 ⬍] results per page.

Results Window ☑ Open search results in a new browser window.

SafeSearch Filtering Google's SafeSearch blocks web pages containing explicit sexual content from appearing in search results.

○ Use SafeSearch to filter my results.
◉ Do not filter my search results.

Save your preferences when finished and **return to search**. [**Save Preferences**]

©2001 Google

above: Visitors can use preferences to customize their search results. Different settings that can be changed include Interface Language, Number of Results per page, and SafeSearch Filtering that blocks explicit content from visitors.

Take the power of Google with you anywhere on the web.

The new Google Toolbar(TM) increases your ability to find information from anywhere on the web and takes only seconds to install. The Google Toolbar is available free of charge and includes these great features:

- **Google Search:** Access Google's search technology from any web page.
- **Site Search:** Search only the pages of the site you're visiting.
- **Word Find:** Find your search terms wherever they appear on the page.
- **Highlight:** Highlight your search terms as they appear on the page, each word in its own color.
- **PageRank:** See Google's ranking of the current page.
- **Page Info:** Access more information about a page including similar pages, pages that link back to that page, as well as a cached snapshot.

You can customize the layout of your toolbar to include features such as "I'm Feeling Lucky", Google Web Directory, and a button that takes you directly to the Google website. If you are still not convinced, take a look at the help page for a complete rundown of what the Google Toolbar can do for you.

System Requirements

At this time, the Google Toolbar is only available for Internet Explorer. We are currently looking into the feasibility of implementing the Google Toolbar for other systems.

- Windows OS
- Internet Explorer 5.0+

I want the Google Toolbar!

Home

All About Google

Search Tips
Overview
Basics of Search
Interpret Results
Refine Search
Personalize Google
Special Features
FAQ

Other Ways To Google
Overview
Special Searches
▸ Google Toolbar
Browser Buttons
Wireless
Googlify your Browser
Google Web Directory

Our Technology
Why use Google
Benefits of Google

Find on this site:

Search

We have further simplified our interface for your wireless device.

Google's adaptable search technology can be accessed from any number of devices, such as WAP-ready phones, Palm V and Palm VII handhelds, and ePodsOne Internet appliances. Whatever language or platform you're using, Google lets you search the web with ease, speed and accuracy.

Google Search using a WAP-ready mobile telephone

Before following the directions below, you must subscribe to an Internet service provider specifically tailored for WAP phones.

Step A

1. On your mobile phone's Internet menu, select the button that corresponds to "menu".

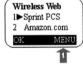

Step B

1. Select "Go to website..." or equivalent from the menu options.
2. Press the button that corresponds to "OK".

Step C

1. When prompted for a site name or URL, enter "Google" using your phone's keypad. If your phone does not accept "Google", enter "wap.google.com".
2. Press the button that corresponds to "OK".

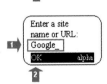

Read more about Google's search on WAP-ready phones.
Read our "Google Goes Mobile" press release.

Home

All About Google

Search Tips
Overview
Basics of Search
Interpret Results
Refine Search
Personalize Google
Special Features
FAQ

Other Ways To Google
Overview
Special Searches
Google Toolbar
Browser Buttons
▸ Wireless
Googlify your Browser
Google Web Directory

Our Technology
Why use Google
Benefits of Google

Find on this site:

Search

above and left: Google is working to expand its brand both through offerings such as the Google toolbar and through integrating its service with wireless technology. By adapting itself to technological advances, Google stays in the forefront of its users' minds.

make it mine

There are two methods for allowing your customers to tailor or modify their experience on your website—*customization* and *personalization.* While these two terms are sometimes used synonymously to characterize "the desired output in the shortest possible time within effort," the two methods offer distinctly different rewards for the website and the customer.

Regardless, the end goal is to target the customer and increase customer intimacy.

Customization enables the users to explicitly modify their experience through technological means. The best examples of this method are the portal sites like My Yahoo. Based on a loosely defined template, custom pages show only the information chosen by users, such as local weather, news, and favorite sports teams. The barrier to entry of this method is the amount of time a user has to invest in making choices. Assuming the desired result has value, it is this investment, however, that can breed intense loyalty and foster repeat visits. For a website, customization can allow for targeted (and therefore more expensive) advertising. Be aware that users' privacy is paramount in getting them to customize. If they feel that the information they give you will be exploited in any way, they will stop using your site altogether.

Customization is critical to the success of e-commerce, especially when it enables a customer to tailor the product itself. Create your own computer system on Dell.com, modify your car's features on CarsDirect.com, or add your signature to shoes on Nike.com. Other customizations, such as a personal greeting on a gift card or a choice of shipping method and wrapping paper, facilitate an intimate buying experience.

Personalization occurs when the experience is modified based on implicit information such as the personal profile of the user or behavior patterns in browsing or purchasing. Amazon.com is the master of this method. On your Amazon home page, you are presented with a list of products based on the products you have purchased in the past or the items that are stored in your shopping cart (an explicit customization). On any Amazon product page, a user can follow a link labeled People who bought this product also bought.... This is information that has been personalized to the product rather than to the user, but the principle is the same.

Another Amazon feature is Visit the page you made. This is a dynamic page full of content based on the click-stream path of the user. This type of personalization occurs without any intervention on the user, so the barriers for the user are nonexistent. However, the effectiveness of this method can be questionable at times because it's based on generalization and best-guess scenarios. A TV ad poked fun at this by saying, "People who bought these donuts also bought...." Another drawback to personalization is that it can sometimes feel like an invasion of privacy—having a creepy, Big Brother effect.

NIKEiD

At NIKE iD, we're **pretty pumped up about personalization** — about giving you new ways to be original.

Find out what personalization's all about. Take a tour through the many ways people sound off, show their style, set down their signatures and strut their stuff. Get ready to enter iD's world of personalization. It's bound to make an impression! click to begin your experience

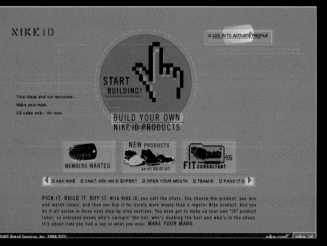

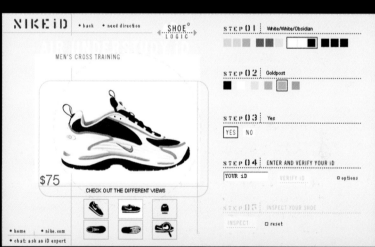

above: The Nike ID line is directed at people who want to customize their shoes. The customer can define style and color and even add a personal statement.

right: If the customer is unsure which shoe they want, Nike's Product Recommender personalization engine steps in to provide choices that will generally match their athletic needs.

SPINNER.COM

UNITING INTERESTS

The first rule of portal design is making sure the structure accommodates the wide range of visitors the site will attract. This goes without saying for general-interest portals like Ask Jeeves or Netscape, but it is essential for niche portals as well. Music portal Spinner.com balances a wide variety of musical tastes with a destination that allows visitors quick access to the musical information they seek.

right: With the diverse musical tastes represented on the Spinner site, the design had to accommodate the variety of users who would be visiting the site. Spinner's approach was to keep the pages as simple and streamlined as possible, allowing photography of the different artists to carry the design.

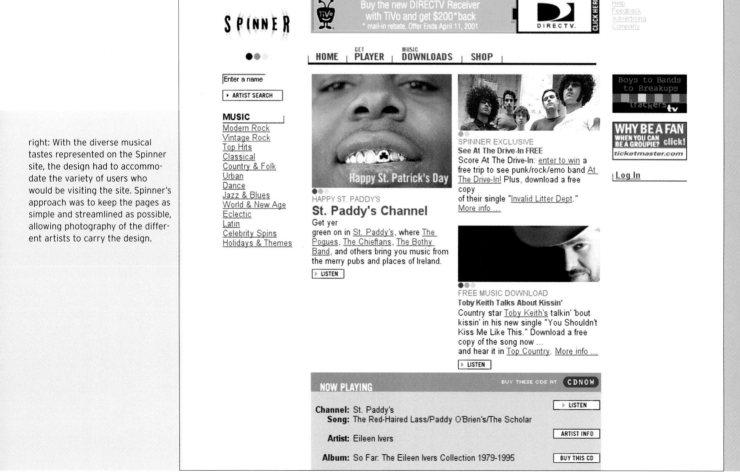

Workshop

Spinner.com is a San Francisco–based Internet portal for music lovers featuring artist and genre information, Internet radio, and direct links to purchases.

What Works

Although a variety of musical tastes are accommodated on Spinner.com—everything from merengue to hair bands—the structure of search and navigation is static. If visitors are searching for a particular artist or band, they can search by keyword—if they want to explore a certain genre, they can click through the categories to see what's offered. Comprehensive information about the artists is included (discography, bio, brief history). And the site provides streaming Internet radio in thirteen different genres and more than 150 different channels.

"The site needed to be fun, light, and entertaining to create an appropriate atmosphere for a music audience," says Ann Burkhart, Spinner.com's communications manager. "Since Spinner has such a diverse musical offering, the design had to have a look that welcomes users regardless of their musical tastes. Spinner accomplishes this by removing extraneous background noise and simplifying the pages, using the strength of our images to communicate this variety without overwhelming the user."

Work Wisdom

Technological extras make the site experience even richer. This includes access to a database with in-depth information on thousands of artists, the ability to see what's Now Playing on highlighted channels throughout the site and the display of charts for the top twenty-five songs on each channel. The site also enables users to book-mark songs on their personal SongPads for future reference and save channel presets to My Favorites, both of which are accessible from the site and the player. "By keeping users closer to the music they love, Spinner can continue to build a loyal following of listeners," says Burkhart.

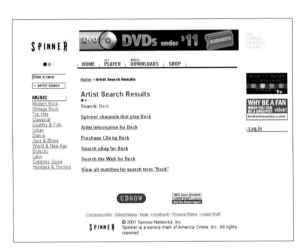

above and right: There are a variety of different ways users can search the Spinner site. If they know the name of the artist, they can simply use the keyword search field, which brings up a variety of different returns for a variety of types of queries. Results include Spinner channels that play the artist, offer artist information, provide the opportunity to purchase CDs, and more.

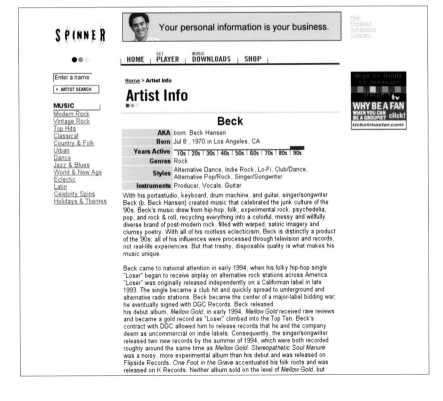

above: Special Spinner promotions and contests keep visitors coming back. But the promotions also serve as a great way to introduce new music to visitors.

right: Unlike conventional radio, Spinner Internet radio doesn't include DJ chatter or commercial interruptions. But Spinner gives the DJs a voice in their DJ bio section, where visitors can learn more about the people programming each channel.

far right: Spinner includes live streaming audio broadcasting through the weekly two-hour Ground Zero show. The structure of Ground Zero is more like traditional radio, with interviews and live, in-studio performances by different artists.

SPINNER

● ●○

Camera & Video Equipment is Our Business.

Help
Feedback
Advertising
Company

HOME | GET PLAYER | MUSIC DOWNLOADS | SHOP |

Enter a name
▶ ARTIST SEARCH

GENRES
Modern Rock
Vintage Rock
Top Hits
Classical
Country & Folk
Urban
Dance
Jazz & Blues
World & New Age
Eclectic
Latin
Celebrity Spins
Holidays & Themes

MODERN ROCK
90s Rock
All Rock
Alt.80s
Alt.90s
Alt.Country
Alt.Now
Brit Pop
Classic Punk
EuroPop
Extreme Metal
Gothic
Great Guitar
Hair Metal
Heavy Rock
Indie Rock
Industrial
Jam Bands
Metal
Mod Christian

Home > Modern Rock

Modern Rock

Classics not cuttin' it? Check out Modern
Rock for fresh Brit pop, alt.country, extreme metal, modrockgrrls, and much more.

● ●○

NOW PLAYING CDNOW

90s Rock
"Standing Outside A Broken Phone" ▶ LISTEN
Primitive Radio Gods

Modernmix
"Take A Picture" ▶ LISTEN
Filter

Swing Dance
"Catch 'Em In The Act (F. Dr. John)" ▶ LISTEN
The Max Weinberg 7

Mod Christian
"Give Myself Away" ▶ LISTEN
Rebecca St. James

Hair Metal
"Heartbreak Blvd" ▶ LISTEN
Shotgun Messiah

View All Channels

DJ BIO
Meet the DJ: Michele Flannery
Our Senior Alt.Music Director is all about programming freedom; just don't try to make her play "Aqualung." Meet

WHAT'S NEW

See At The Drive-In FREE

Score At The Drive-In: enter to win a free trip to see punk/rock/emo band At The Drive-In! Plus, download a free copy of
their song "Invalid Litter Dept.". More info ...

SPINNER EXCLUSIVE
Ground Zero
This week, Lifehouse lead singer Jason Wade chats with GZ host Chris Douridas about their rapid rise on the rock charts. More info ...
▶ LISTEN

Boys to Bands to Breakups
trackers tv

WHY BE A FAN
WHEN YOU CAN BE A GROUPIE? click!
ticketmaster.com

| Log In

SPINNER

● ●○

UP TO 30% OFF EVERYTHING
MUSIC, MOVIES, AND MORE.
Sale ends Monday, March 12, 2001 @ 9AM EST.

CLICK HERE
CDNOW

Help
Feedback
Advertising
Company

HOME | GET PLAYER | MUSIC DOWNLOADS | SHOP |

Enter a name
▶ ARTIST SEARCH

GENRES
Modern Rock
Vintage Rock
Top Hits
Classical
Country & Folk
Urban
Dance
Jazz & Blues
World & New Age
Eclectic
Latin
Celebrity Spins
Holidays & Themes

MODERN ROCK
90s Rock
All Rock
Alt.80s
Alt.90s
Alt.Country
Alt.Now
Brit Pop
Classic Punk
EuroPop
Extreme Metal
Gothic
Great Guitar
Hair Metal
Heavy Rock

Home > Modern Rock > 90s Rock

90s Rock
Smells Like Alterna-teen Spirit: A Decade Of Modern Rock Hits

● ●○

This Week's Top 25 Songs
The 25 most played songs, as selected by our DJs and ranked by listener ratings, for the week ending Mar 11, 2001.
▶ LISTEN
Email this channel to a friend

TOP 25 SONGS BUY THESE CDS AT CDNOW

1
Song: Burden In My Hand ARTIST INFO
Artist: Soundgarden BUY THIS CD
Album: A-Sides

2
Song: Unglued ARTIST INFO
Artist: Stone Temple Pilots BUY THIS CD
Album: Purple

3
Song: Closer ARTIST INFO
Artist: Nine Inch Nails BUY THIS CD
Album: The Downward Spiral

4
Song: I Stay Away ARTIST INFO
Artist: Alice In Chains BUY THIS CD
Album: Jar Of Flies

Boys to Bands to Breakups
trackers tv

WHY BE A FAN
WHEN YOU CAN BE A GROUPIE? click!
ticketmaster.com

| Log In

above and left: Users can explore different categories by selecting a genre, then drilling down by choosing a channel based on their interest. Links to songs in that category currently playing on different channels are included, along with links to the top twenty-five songs each week in the different categories.

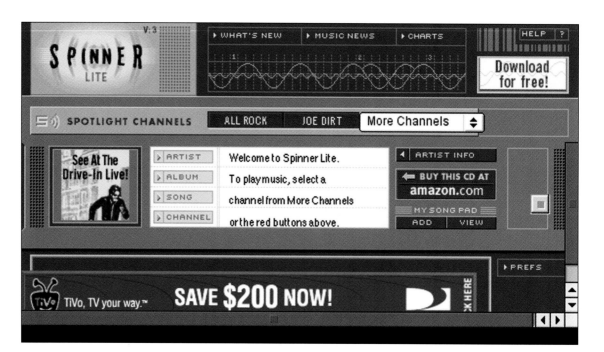

above and right: The Spinner Player is the console that allows users to manage the different channels of Spinner.com's Internet radio. From here, users can navigate to different channels, add a song to My Song Pad, learn more about the artist, or buy the CD.

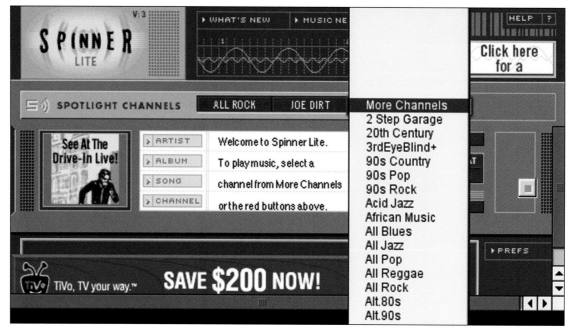

SPINNER

● ●○ ●

Help
Feedback
Advertising
Company

HOME | GET PLAYER | MUSIC DOWNLOADS | SHOP |

Enter a name
▶ ARTIST SEARCH

MUSIC
Modern Rock
Vintage Rock
Top Hits
Classical
Country & Folk
Urban
Dance
Jazz & Blues
World & New Age
Eclectic
Latin
Celebrity Spins
Holidays & Themes

Home > My Songpad

SongPad

SongPad is the perfect way to remember your favorite songs. Use it to capture vital information -- artist, album, and song name -- for up to 100 personal entries. Just click the "add" button from the Spinner Plus player whenever you hear something you like and we'll save it for you. Then return to your SongPad to learn about all the artists you heard and purchase their CDs! Note: The songs in your songpad are not available for playback.

DELETE CHECKED SONGS BUY THESE CDS AT CDNOW

☐ **Song:** Ball And Chain ARTIST INFO
 Artist: Social Distortion BUY THIS CD
 Album: Social Distortion

☐ **Song:** Music (Deep Dish Dot Com Radio Edit) ARTIST INFO
 Artist: Madonna BUY THIS CD
 Album: Music (Maxi Single)

☐ **Song:** Green Eyes ARTIST INFO
 Artist: The Union BUY THIS CD
 Album: To Be Good At Something

 Song: June ARTIST INFO

Boys to Bands
to Breakups
trackers tv

WHY BE A FAN
WHEN YOU CAN
BE A GROUPIE? click!
ticketmaster.com

Hello Lisa
My Profile
My Song Pad

SPINNER

● ●○ ●

Help
Feedback
Advertising
Company

HOME | GET PLAYER | MUSIC DOWNLOADS | SHOP |

Enter a name
▶ ARTIST SEARCH

MUSIC
Modern Rock
Vintage Rock
Top Hits
Classical
Country & Folk
Urban
Dance
Jazz & Blues
World & New Age
Eclectic
Latin
Celebrity Spins
Holidays & Themes

Home > Music Downloads

Music Download Showcase

FEATURED DOWNLOAD
at the drive-in
invalid
litter dept.
CLICK HERE FOR MORE INFO

FEATURED DOWNLOAD
Semisonic
Chemistry &
Closing Time
CLICK HERE FOR MORE INFO

FEATURED DOWNLOAD
Toby Keith
You Shouldn't
Kiss Me Like This
CLICK HERE FOR MORE INFO

FEATURED DOWNLOAD
matthew good band
Hello Time Bomb
CLICK HERE FOR MORE INFO

Spinner's Download Showcase features individual downloads from today's most popular artists. All tracks are in a digitally secure format, which is designed to prevent artists from being taken advantage of. Consequently, each track will only playback for 30 days after you download it, when its license automatically expires. Take the following steps to ensure a successful download.

S▶1 Make sure you either have Winamp 2.2 or higher or MS media player 6.02 or higher.

S▶2 Right-click on the download link for the song you want and save it to a folder where you can easily find it.

S▶3 The first time you open the file, make sure you are connected to the Internet. Since it's a secure file, the song needs to retrieve its license file before you can play it.

S▶4 Launch your music player and open the file. A page will open in your Web browser confirming that you have received the file. Click the

Boys to Bands
to Breakups
trackers tv

WHY BE A FAN
WHEN YOU CAN
BE A GROUPIE? click!
ticketmaster.com

Hello Lisa
My Profile
My Song Pad

above: The ability to bookmark songs by adding them to the SongPad allows visitors to save certain songs for future reference and be only a click away from more information about the song and artist.

left: Different songs are featured for download, allowing visitors to sample songs separately from the radio stations for thirty days, after which the songs expire.

NETSCAPE.COM

EVOLUTION OF INFORMATION

Many of the best-known portals have been around since the Web boom in the early '90s. But as the Internet's presence has evolved from a novelty to a mammoth font of information, the structure of many of these portals hasn't changed accordingly. To further complicate matters, the amount of information online continues to grow exponentially, meaning that the same site structures are charged with organizing and accessing significantly more information.

Netscape.com is an exception to the rule, eschewing the common approach of dumping every possible link on its portal home page. Its sleek presentation of information is attractively organized in a way that anticipates future growth and focuses on the user's needs.

right: A site doesn't have to be ugly to accommodate links to a lot of information. The redesign of the Netscape site is a study in economy of space. The wide number of subjects and links to information are stylishly organized into tabbed areas, while navigation and features take residence in the upper half of the page.

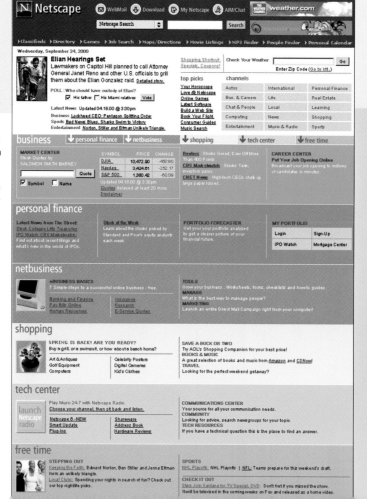

above: One of the keys to the site's new design was the hierarchy the elements were given on-screen. Buttons along the top provide immediate links to some of the most-sought features of the Netscape site. A keyword-search field anchored to this element allows visitors with an immediate search in mind to get right to it. And the links featured in a smaller size below provide easy access to popular destinations.

Workshop

Jessica Helfand | William Drenttel, a Falls Village, Connecticut–based design consultancy, was hired to redesign the Netscape home page.

What Works

The main issue the designers confronted when planning the redesign was giving structure to the massive amount of information included on the site. The starting point for this endeavor? Analyzing user studies.

"Previously, Netscape was organized on a Yahoo! model," says William Drenttel, principal of Jessica Helfand | William Drenttel. "It had over 150 links organized around channels. We deconstructed the click-through data to understand user patterns, and we looked for different models to organize the page. In the end, we placed greater emphasis on the search and news. And we deemphasized traditional channel navigation to create six larger content zones. It was our belief that a more understandable structure would also be more navigable."

The result is a design that effectively organizes the information for users, packaging the content into different content areas with context, rather than providing a blind list of search results. Different elements are pulled out to give them more weight. "Rather than viewing Netscape as a portal or gateway, we aimed to make it a resource center with superior information organization and usefulness. There is little future in only being a page of links elsewhere," says Drenttel.

Work Wisdom

An enormous site like Netscape had to be constructed to facilitate future growth. Portal designers should always have one eye to the future, and the structure has to be able to fold these elements in, without their looking awkward or "tacked on." In fact, the Netscape site has been redesigned again since Jessica Helfand | William Drenttel initially designed it—the news zone, placement of channels, and number of content zones has changed. But the overall look remains the same.

"When you're designing something that is fluid, you're not designing a page or a site, you're designing an approach to structure," says Drenttel. "A site can change dramatically, but the design approach should still be valid. Thus, the same design structure and vocabulary remain six months after our redesign, and it's still evolving."

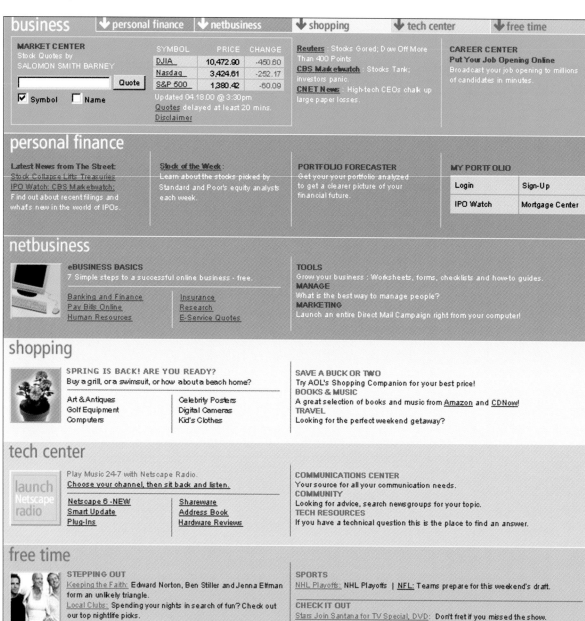

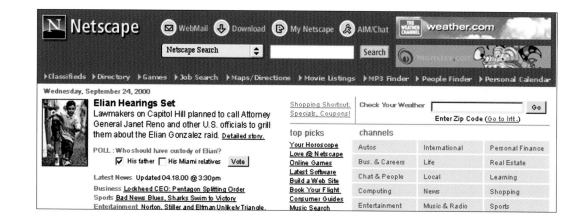

above: A relatively low-tech solution helps users navigate the great amount of information on the Netscape home page. Simple anchor tags embedded in the top tabs enable users quickly jump to the information they are looking for, preventing the need for the page to reload each time someone clicks to a new section.

right: User studies revealed that Netscape visitors wanted to see more emphasis on navigation, less emphasis on channels. The redesigned page balances the treatment of the navigation and search elements with the top picks and channels. All elements are organized tidily on the page so that everything is visible at a glance.

netbusiness

eBUSINESS BASICS
7 Simple steps to a successful online business - free.

Banking and Finance
Pay Bills Online
Human Resources

Insurance
Research
E-Service Quotes

TOOLS
Grow your business : Worksheets, forms, checklists and how-to guides.
MANAGE
What is the best way to manage people?
MARKETING
Launch an entire Direct Mail Campaign right from your computer!

tech center

Play Music 24-7 with Netscape Radio.
Choose your channel, then sit back and listen.

Netscape 6 -NEW
Smart Update
Plug-Ins

Shareware
Address Book
Hardware Reviews

COMMUNICATIONS CENTER
Your source for all your communication needs.
COMMUNITY
Looking for advice, search newsgroups for your topic.
TECH RESOURCES
If you have a technical question this is the place to find an answer.

shopping

SPRING IS BACK! ARE YOU READY?
Buy a grill, or a swimsuit, or how about a beach home?

Art & Antiques
Golf Equipment
Computers

Celebrity Posters
Digital Cameras
Kid's Clothes

SAVE A BUCK OR TWO
Try AOL's Shopping Companion for your best price!
BOOKS & MUSIC
A great selection of books and music from Amazon and CDNow!
TRAVEL
Looking for the perfect weekend getaway?

above: One of the site's goals is to provide visitors not just with information, but with context for that information. Each subsection pulls out a feature and includes links to other relevant topics. "We weren't just viewing the portal as a gateway," says Drenttel. "We were trying to organize the information on the page so it was useful information, not just links."

Helfand | Drenttel
William Drenttel, creative director
Jeffrey Tyson and Dan Bowman,
designers

ABOUT.COM

SEARCHING IN CONTEXT

One of the biggest gripes people have about the Internet is its impersonal nature. Portal sites tend to be the greatest offender—results from queries tend to be hit-or-miss at best. And the descriptions following them are often truncated descriptions or mismatched copy picked up from the site's home page. About.com takes a different approach to portals by allowing experts in various subject areas to hand-pick recommended sites and introduce a little human interpretation into the search/result process.

right: It's About.com's mission to put a little human interaction between visitors and their searches. Rather than an exhaustive, dynamically created hit-or-miss list of every possible site available for search topics, About.com personal guides handpick links in more than seven hundred different subject channels.

© 2001 About.com, Inc. Used by permission of About.com, Inc. which can be found on the Web at http://www.about.com. All rights reserved.

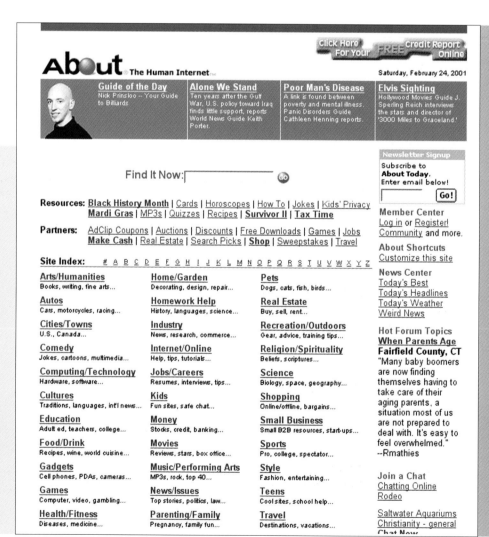

right: One of the challenges for a site like About.com is finding a way to entice users into the different corners of the site. For this reason, designers use the site's home page to draw attention to different features, such as each day's Spotlight Guide of the Day.

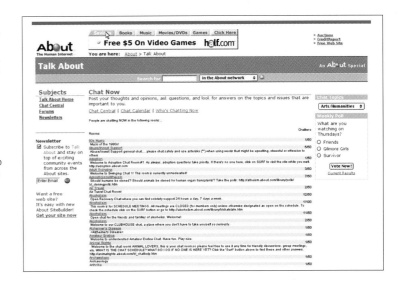

Workshop

About.com is a New York City–based Internet portal.

What Works

At About.com, an actual human being acts as a custodian for each category area. Each featured link is pre-screened and approved, with descriptive copy written by the subject guide. Rather than their offerings being a one-way relationship, the guides all have e-mail addresses so that users can contact them directly. And although the site links to hundreds of sites all over the world, About.com is a source of information itself, with original articles and how-to sections.

The site was inspired by the decidedly impersonal nature of the Web. "When the Web debuted, it was a mishmash of information," says Scott Kurnit, chairman and CEO of About.com. "Search engines were the first attempt at organizing this information, but the human touch was still missing. We thought we could do it differently. By using the guides, professionals with great expertise and passion, to lead the way, we make for a better experience."

right: Membership in any community has its rewards, and About.com is no exception. Registered members of the site receive free e-mail, full access to the forums, the use of chat features, and even personal Web pages (assembled with the assistance of About's SiteBuilder).

Work Wisdom

About.com draws on its own visitors to both build a sense of community and provide new information. Registered users can create their own websites, open a free e-mail account, and participate in chat and discussion boards. The sense of community adds another dimension to the site, with visitors interacting both with each other and with the featured guides.

"Each of the seven hundred separate minisites has its own community," says Kurnit. "Community done right is good business. The critical difference with About.com is that as well as having a search engine of information of links of different issues, we also have a place where visitors can hang out with other people who share their interests either in the chat rooms or forums."

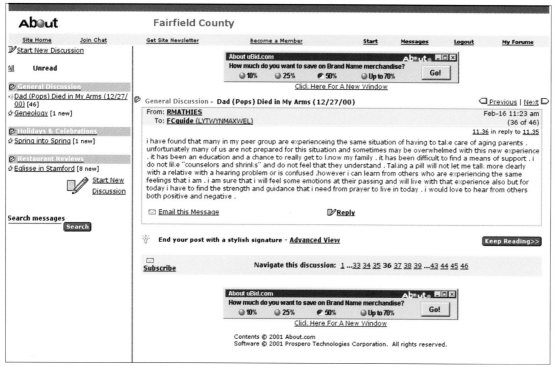

About — Fairfield County

Site Home | Join Chat | Get Site Newsletter | Become a Member | Start | Messages | Logout | My Forums

Start New Discussion

All Unread

General Discussion
·) Dad (Pops) Died in My Arms (12/27/00) [46]
Geneology [1 new]

Holidays & Celebrations
Spring into Spring [1 new]

Restaurant Reviews
Eglisse in Stamford [8 new]

Start New Discussion

Search messages
[Search]

About uBid.com
How much do you want to save on Brand Name merchandise?
○ 10% ○ 25% ● 50% ○ Up to 70% [Go!]
Click Here For A New Window

General Discussion - Dad (Pops) Died in My Arms (12/27/00) ◁ Previous | Next ▷

From: **RMATHIES** Feb-16 11:23 am
To: **FCguide** (LYTWYNMAXWEL) (36 of 46)
 11.36 in reply to 11.35

i have found that many in my peer group are experienceing the same situation of having to take care of aging parents . unfortunately many of us are not prepared for this situation and sometimes may be overwhelmed with this new experience . it has been an education and a chance to really get to know my family . it has been difficult to find a means of support . i do not like "counselors and shrinks" and do not feel that they understand . Taking a pill will not let me talk more clearly with a relative with a hearing problem or is confused ,however i can learn from others who are experiencing the same feelings that i am . i am sure that i will feel some emotions at their passing and will live with that experience also but for today i have to find the strength and guidance that i need from prayer to live in today . i would love to hear from others both positive and negative .

✉ Email this Message ✏ Reply

💡 End your post with a stylish signature - **Advanced View** [Keep Reading>>]

✉ Subscribe Navigate this discussion: 1 ...33 34 35 36 37 38 39 ...43 44 45 46

About uBid.com
How much do you want to save on Brand Name merchandise?
○ 10% ○ 25% ● 50% ○ Up to 70% [Go!]
Click Here For A New Window

Contents © 2001 About.com
Software © 2001 Prospero Technologies Corporation. All rights reserved.

About — The Human Internet

Mercedes SLK 230

> **Auctions**
> **CreditReport**
> **Free Web Site**

You are here: About > How To

How To

Search for [] in [How To ▼] ⊙

Index
About Australia
About Canada
About India
About Ireland
About UK
Arts/Humanities
Autos
Cities/Towns
Comedy
Computing/Technology
Cultures
Education
Food/Drink
Gadgets
Games
Health/Fitness
Hobbies
Home/Garden
Homework Help
Industry
Internet/Online
Jobs/Careers
Kids
Money
Movies
Music/Performance
News/Issues

Today's Pick
Sat, Feb 24, 2001

How to Cook Oven Barbecued Ribs
From African-American Culture Guide R. Jeneen Jones

Difficulty Level: Easy
Time Required: 3 hours

Whether you like spareribs, beef or baby back ribs, this recipe will produce a mouth-watering entree without a grill.

1. You will need these ingredients: 1 teaspoon onion powder; 1/2 teaspoon cumin; 1/2 teaspoon salt; 1/2 teaspoon black pepper; 1/2 teaspoon celery salt.
2. Combine the tomato puree, brown sugar, Worcestershire sauce, chopped onion and brown mustard in a small pot and cook over low heat while stirring often for about an hour.
3. continue...

Related How To's:
* How To Cook Baked Macaroni
* How To Cook a Sweet Potato Pie

Clean It Up How To's
Kitchens are often the most-used room in the house, so it's no wonder they seem to always need cleaning. Get the job done faster with help from these kitchen cleaning tips.

* Clean a Coffee Maker
* Clean the Oven Safely
* Clean a Carbon Steel Wok
* Clean a Microwave Oven
* Clean and Season Cast Iron

Wacky How To's

* How to React in a Killer Bee Attack
* Check For Net Addiction

This Week
Mon Replace a Screen
Tue Respond to a Bad Review
Wed Write to a Celebrity
Thu Play Spades
Fri Cook Oven Barbecued Ribs

Newsletter
Sign up here for our daily How To Newsletter. Unless, of course, you already know everything.

[Enter Email] 🔘

Wireless
Get **How To's** on your PDA! Sign up with one of our partners to access our **How To's** from wherever you are.

Go America — Wireless Internet Services

right: Visitors know that the information on About.com is fresh, and this is especially evident from the site's attention to current events. About.com's News Center offers up-to-date discussion, links, and resources that are updated daily.

below: In contrast to the often cryptic site descriptions many search engines provide, About.com's site synopses are written by the guides for each section, letting the visitor know that the sites have been screened and carefully considered before being recommended.

About — The Human Internet

Click on the 33 for a chance to win $31,000,000

58 19 66 71 33 49 25

> Auctions
> CreditReport
> Free Web Site

You are here: About > Arts/Humanities > Publishing

Publishing
with **Wendy Butler** Your Guide to One of Over 700 Sites

Search for [] [in this topic site ▼] GO

Home · Recent Articles · Visit Forums · Chat Live · Contact Guide · Free Newsletter

Subjects
Awards
Book Fairs
Bookselling
Canadian
Career/Networking
Children's Books
Contracts
Copyright
Distribution
Editorial
Genres/Categories
Get Published
Illustration
Indexing
Libraries
Literary Agents
Marketing
People/Profiles
Printers
Publishers
Self Publishing
Software
Statistics
Translation
Vendors/Services

Audiobooks

Post to the Bulletin Board

I check the Bulletin Board regularly. Post your questions or comments and you'll get input from a variety of voices. I am away from my office frequently in the spring and summer, and often am able to access the bulletin boards more frequently than I am able to download my mail.

Frequently Asked Questions (FAQ)

(These questions and answers come right out of my weekly email. The answers are not always comprehensive, but should give you a good starting point to do further research on your own. I am not a lawyer. If you **really** need legal advice, consult someone who **really** knows what they are talking about!)

Q. *Will you review my book/product?*
If you've got something my readers should know about, I certainly will! Drop me an email, and I'll let you know where to send your package.

Q. *Will you review e-books?*
I'll review anything I can read. For now, that **excludes** ebooks formatted for proprietary e-book readers like Rocket eBook and SoftBook. I have an aversion to Windows .EXE files, but if your book is intriguing enough, I'll probably take a look. I'll also accept PDF and LIT files if you warn me in advance that you're sending one. You can also upload any files to my iDrive - though do send me an email letting me know it's there.

Q. *How do I get my Web site listed on one of your pages?*
1. Check the links list to make sure I have a category for sites such as yours. If there isn't one, feel free to suggest a new category.
2. Make sure your site has value. Sites with articles, information, and other good content are more likely to receive a listing than a page with nothing but a sales pitch.
3. Test your site to make sure it works with **all** browser types. I surf using Linux and Netscape about 50% of the time, and if I can't get in to your site because of FrontPage or Javascript errors, I can't list it.
4. Post a message to the 'Web Sites' folder on the bulletin board or email me to submit your URL.

Related Sites
from About & Partners
Advertising
Book Collecting
Creative Writing for Teens
Desktop Publishing
Freelance Writers
Librarians and Library Science
Newspapers: U.S.
Newspapers: World
Writers' Exchange

Also Recommended
Apply to become a partner for this site.

Magazine Offer

FREE OFFER

Advertising
Spedia.com
Get $150 in an Hour,
Signing Up at Sites

About — The Human Internet

× About Dating About® _ □ ×
What are you looking for? [All of the above ▼] [OK]

> Buy CDs Now
> Auctions
> CreditReport
> Free Web Site

You are here: About > Arts/Humanities > Publishing

Publishing
with **Wendy Butler** Your Guide to One of Over 700 Sites

Search for [] [in this topic site ▼] GO

Home · Recent Articles · Visit Forums · Chat Live · Contact Guide · Free Newsletter

Subjects
Awards
Book Fairs
Bookselling
Canadian
Career/Networking
Children's Books
Contracts
Copyright
Distribution
Editorial
Genres/Categories
Get Published
Illustration
Indexing
Libraries
Literary Agents
Marketing
People/Profiles
Printers
Publishers

Wendy Butler
publishing.guide@about.com

Wendy Butler is a writer, publisher, and partner in a company offering electronic publishing services to trade, academic and medical journals.

Professional Experience: Always passionate about books, Wendy joined the publishing industry after college, first with a university press, then with a mid-sized trade publisher.

Education: Wendy graduated from the University of Alberta with a B.A. in History.

From Wendy Butler: "For the last several years, finding Internet resources for publishers has been a hobby for me, and I know that there is still far more to discover. The book industry is in a state of rapid change, and it's more important than ever to have up-to-date news and information about the issues that affect you. I hope that here, on the About Publishing site, you'll be able to find everything you need to help your publishing company prosper."

Email this page!

Related Sites
from About
Advertising
Book Collecting
Creative Writing for Teens
Desktop Publishing
Freelance Writers
Librarians and Library Science
Newspapers: U.S.
Newspapers: World
Writers' Exchange

Also Recommended
Apply to become a partner for this site.

Magazine Offer

left and below left: It's not enough to have a "real person" connected with the different subjects on the site–in order to be the "Human Internet" About.com aims to be, the site must enable visitors to communicate directly with the guides if necessary. Brief bios give information on each guide, and each one provides an e-mail address at which the guide can be contacted.

© 2001 Wendy Butler (http://publishing.about.com), About.com, Inc. Used by permission of About.com, Inc., which can be found on the Web at http://www.about.com. All rights reserved.

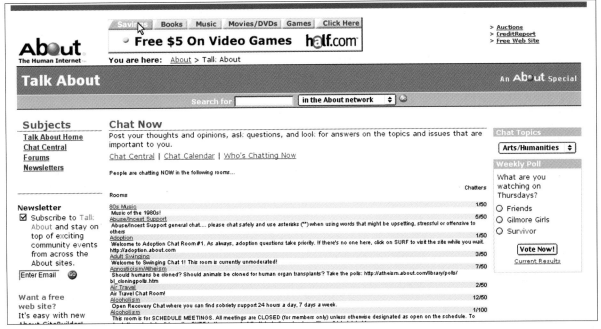

ASKJEEVES.COM

COMMUNICATION IN HUMAN TERMS

The language of the Web isn't exactly user-friendly. Most of the cues on Web pages are single words that by themselves don't have much use here in real life (Submit, Delete, Clear Form, Login). Misspell one letter in a URL and you're lost. And search engine results tend to be as obscure and vague as the string of words used in the query itself. The problem lies in the fact that the way people communicate with each other isn't the way computers were set up. Ask Jeeves is a search portal that understands queries posed in natural language.

right: In order to provide users with a more humanistic experience to searching the Web, the site offers Jeeves, an Internet butler who serves up search results as users ask for it. You don't find Internet lingo anywhere—just friendly copy inviting users to ask questions and get results.

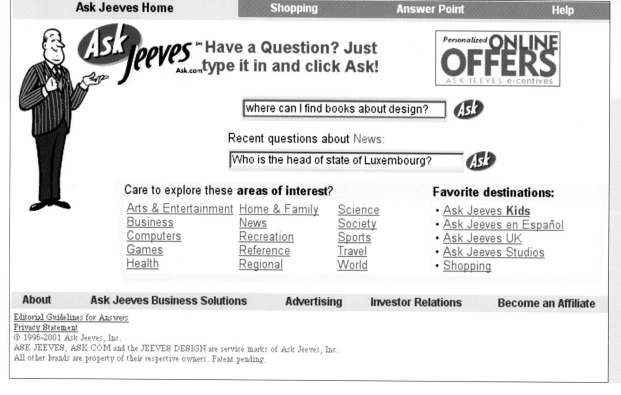

Workshop

Ask Jeeves is an Internet search engine whose technology is licensed to a variety of other private sites. The offices are located in Emeryville, California.

What Works

There's no learning curve to searching on Ask Jeeves. Using the gimmick of a butler to answer questions, the site doesn't force you to phrase your questions a certain way or use a complicated advanced-search form. Instead, users simply phrase questions in plain English. If you're looking for a book on mallard ducks, you just type "Where can I find books about mallard ducks?" instead of trying to use complicated Boolean expressions.

Both technology and the contribution of human editors are responsible for delivering results. The technology uses natural-language parsing software, a data-mining process, and maintenance tools combined with the cognitive strengths of human editors. After a query, the search results offer a variety of different possible answers to the question also in plain English. Drop-down menus are used to help target the search. Rather than including hundreds of results, the search engine fits everything on one page, with the results that best fit the query; links to results others with similar questions got; links to related searches; and links to results on other search engines. By keeping all this on one page, Ask Jeeves prevents visitors from getting lost in a sea of results pages. The language of the results helps users know immediately if the information they seek is available.

Work Wisdom

Ask Jeeves not only provides links to content but also offers the site as a networking hub where visitors can post and reply to specific questions in the message boards. This approach serves two practical purposes—it taps its own users for their knowledge, and it builds the content of the site into a growing searchable database of questions and answers.

above and below: The friendly format of Ask Jeeves makes it an easy introduction to the Web for children. The Ask Jeeves Kids area allows children to search the Web in a kid-friendly environment, with special areas like the Study Tools reference desk, Advice, and Net-Mom Picks.

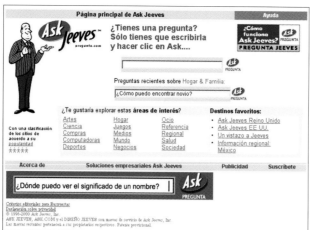

above: The Ask Jeeves brand has expanded internationally, with a Spanish site as well as sites specially designed for the U.K., Australia, and Japan.

right: It's not essential to have a question in order to be able to use Ask Jeeves. To browse individual categories without a specific question in mind, users can use the category links to explore the options within a specific category.

below: Ask Jeeves keeps search results to a manageable single page. Results are prioritized first by answers to the exact question or approximate question, in the site's estimation. Below are links to similar questions and related searches. Finally, Ask Jeeves offers links to three different search engines if the user's answer still isn't found.

below right: Part of the site's success is in adapting the site's technology to applications. The Butler Bar installs as part of a Web browser so that users can access the search technology and other features from anywhere online.

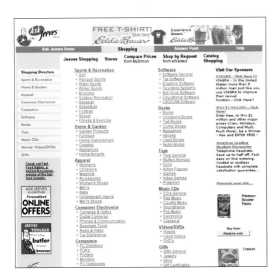

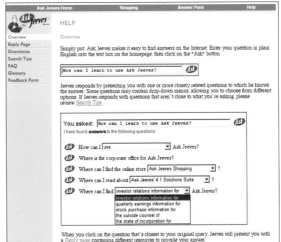

far left: The shopping module for Ask Jeeves allows users to do more than just find merchandise. Jeeves Shopping allows visitors to browse different online stores by category, compare prices, and request specific merchandise.

left: It is crucial to the humanistic philosophy of the site to provide helpful customer service for site visitors. Every page of Ask Jeeves links to the site's Help section, and the Help section follows the same format as the rest of the site.

above: When Jeeves doesn't have all the answers, someone does. Visitors can ask and answer questions themselves in the Answer Point forums. This element of the site not only invests visitors in the site, but also provides a great option for users who can't find answers to their questions through the conventional search.

above right: Users can post whatever questions they want in the forums. Past questions and answers are archived and searchable so people with similar questions can easily find answers.

right: Although anyone can answer questions in the Answer Point section, Ask Jeeves has established some individuals as Enthusiasts who the site has deemed to be experts in particular areas of expertise, providing more reliable advice.

directory

About.com
1440 Broadway
New York, NY 10018
(212) 204-4000
www.about.com

Adobe Systems, Inc.
345 Park Ave.
San Jose, CA 95110
(408) 536-6000
www.splatterpunk.com

Altoids
Callard & Bowser-Suchard, Inc.
P.O. Box 1031
Rye Brook, NY 10573
www.altoids.com

ArtandCulture.com
1045 Sansome St.
Suite 328
San Francisco, CA 94111
(415) 986-6873
www.artandculture.com

Ask Jeeves, Inc.
5858 Horton St.
Emeryville, CA 94608
(510) 985-7400
www.ask.com

Booth Hansen
555 S. Dearborn St.
Chicago, IL 60605
(312) 427-0300
www.boothhansen.com

Burton Showboards
80 Industrial Parkway
Burlington, VT 05401
(800) 881-3138
www.burton.com

Customatix.com
147 South River St., Suite 201
Santa Cruz, CA 95060
(877) 90-SHOES
www.customatix.com

Dotology
750 N. Rush
Suite 2506
Chicago, IL 60611
(312) 335-0378
www.dotology.com

Esquire.com/Hearst Interactive Media
959 Eighth Ave.
New York, NY 10019
(212) 649-2361
www.esquire.com

Idea Integration
582 Market St.
Suite 1300
San Francisco, CA 94104
(415) 646-8712
www.idea.com

Google, Inc.
2400 Bayshore Pkwy.
Mountain View, CA 94043
(650) 330-0100
www.google.com

Hillmancurtis, Inc.
447 Broadway
Fifth Floor
New York, NY 10013
(212) 226-6082
www.hillmancurtis.com

Jessica Helfand | William Drenttel
P.O. Box 159
Falls Village, CT 06031
(860) 824-5040
www.jhwd.com

Juxt Interactive
858 Production Place
Newport Beach, CA 92663
(949) 752-5898
www.juxt.com

K10k.com
speak@k10k.com
www.k10k.com

Lundstrom & Associates Architects
2201 Martin St.
Suite 203
Irvine, CA 92612
(949) 250-1772
www.lundstromarch.com

Mediumrare, Ltd.
Charlotte House
47-49 Charlotte Rd.
London EC2A 3QT
UK
+44 (0) 20 7613-4020
www.mediumrare.net

Netscape.com
466 Ellis St.
Mountain View, CA 94043
(650) 254-1900
www.netscape.com

Nerve.com
520 Broadway 6th Floor
New York, NY 10012
info@nerve.com
www.nerve.com

OVEN Digital
10 Crosby St.
New York, NY
10013
(212) 253-2100
www.oven.com

RedEnvelope
201 Spear St.
Third Floor
San Francisco, CA 94105
(877) 783-2873
www.redenvelope.com

Red Sky Interactive
373 Park Ave. South
Seventh Floor
New York, NY 10016
(212) 659-5700
www.redsky.com

Spinner.com
375 Alabama St.
Suite 350
San Francisco, CA 94110
(415) 934-2700
www.spinner.com

Tiffany & Co.
Fifth Avenue at 57th St.
New York, NY 10022
(212) 755-8000
www.tiffany.com

United States Holocaust Memorial Museum
100 Raoul Wallenberg Place SW
Washington, DC 20024
(202) 488-6100
www.ushmm.org/doyourememberwhen/

Webvan Group, Inc.
310 Lakeside Dr.
Foster City, CA 94404
(650)627-3000
www.webvan.com

ABOUT THE AUTHORS

Lisa Baggerman, author of *Design For Interaction: User Friendly Graphics,* is website manager for Chronicle Books in San Francisco, California. Former senior editor of *HOW* magazine, she has written extensively on design and technology issues. She lives in San Francisco, California.

Shayne Bowman is a design and content consultant with Hypergene.net in Dallas, Texas. Hypergene specializes in creating and displaying content that has one goal: to engage the audience. He lives in Carrolton, Texas.